Zen Doodle Imagination

Create Your Own Zen Doodle Drawings Easy!

By Daniele Ling

Copyright©2016 by Daniele Ling

All Rights Reserved

Copyright © 2016 by Daniele Ling

All rights reserved. No part of this publication may be reproduced, distributed, or transmitted in any form or by any means, including photocopying, recording, or other electronic or mechanical methods, without the prior written permission of the author, except in the case of brief quotations embodied in critical reviews and certain other noncommercial uses permitted by copyright law.

Table of Contents

Introduction	5
Chapter 1 – How to Draw a Zen Doodle Violin	9
Chapter 2 – How to Draw a Zen Doodle Vase?	21
Chapter 3 – Zen Doodle Techniques for Drawing a Young Girl	32
Chapter 4 – How to Draw a Candle with Zen Doodles?	40
Chapter 5 – Learn How to Draw a Padlock and a Key	52
Chapter 6 – Easy Zen Doodle Technique for Drawing Hands Holding a Pen	63
Conclusion	70

Disclaimer

While all attempts have been made to verify the information provided in this book, the author does assume any responsibility for errors, omissions, or contrary interpretations of the subject matter contained within. The information provided in this book is for educational and entertainment purposes only. The reader is responsible for his or her own actions and the author does not accept any responsibilities for any liabilities or damages, real or perceived, resulting from the use of this information.

The trademarks that are used are without any consent, and the publication of the trademark is without permission or backing by the trademark owner. All trademarks and brands within this book are for clarifying purposes only and are the owned by the owners themselves, not affiliated with this document.

Introduction

Having an art as a hobby is a great thing. Instead of watching TV in your spare time, you can do something way more productive. Our advice is Zen doodle drawing as this can be a life-changing hobby. Not only will this craft help you eliminate boredom from your everyday life, it will also engage your mind in a way you wouldn't expect.

This type of art is proven to be great for boosting creativity. With Zen doodling, your rational mind is at rest, but your subconscious is working full-time. Basically, with Zen doodle drawing your mind is free. You are playing by drawing irregular shapes on a piece of paper in a way you did when you were a child. That means that all of your worries will go away now.

The best thing about Zen doodle drawing is that you just can't make a mistake as every line you create is a masterpiece on its own. When there is no pressure, you are not afraid of anything and that's exactly what every person living in the chaotic 21st century needs.

Once you let your mind go and draw the doodles freely, you will start feeling much better, which can have benefits on your whole life. But, apart from making you relaxed, this kind of art can turn you into a real artist. If you do it properly, you might start making some really nice paintings.

If all of the things mentioned above are not enough to make you interested in Zen doodle drawing, then you should keep on reading the book and take a look at the examples we provided for you. Once you see how awesome Zen doodle drawing can be and how easy you can draw them, you will certainly fall in love with this type of art.

This art technique is all about writing simple objects that you then ornament with doodles. The drawing moves done for the ornaments need to repeat themselves in order to achieve a harmony in the drawing. As you're doing this – drawing simple, repeating lines, you'll feel as if you were meditating. But unlike meditation, with Zen doodling, you will produce beautiful works of art.

So instead of worrying the whole day about things that life brings, you can fight them in a beautiful and a rather productive way. Simply, start drawing Zen doodles and you will free your mind from worries, at least for a couple of hours every day.

Another good thing about Zen doodle drawing is that almost anyone in the world can afford it. It's one of the cheapest hobbies, because all you need is a piece of paper and a pen. Instead of expensive material tools, this art requires spiritual things. You need to have open and free mind to do Zen doodling.

For Zen doodle drawing, you will need a piece of blank paper. The next step is to take a pen and draw the first object. It's very important not to think too much about it - simply let your hand do the work! Even if you don't like what you drew, you need to leave it as it is, without making any corrections – that's one of the basic principles of Zen doodling.

When you are finished with drawing the outline of the object, you need to ornament it with a particular pattern. Tracery may consist of triangles, squares, circles, dots etc. Actually, you can use any shape you like for Zen doodle ornaments. Simply let your imagination go wild and draw everything that comes to your mind, whether it's flowers, snowflakes, circles or any other shape.

What matters about Zen Doodle drawing is that the eraser is never used. That sends the message that there is no possibility of turning back and correcting errors. There is only here and now and the only thing you do is draw some patterns with the ubiquitous care and concentration.

Surely the best way to demonstrate Zen Doodle drawing is with examples. So, keep on reading this book, because what follows are how-to-do instructions on drawing simple, yet beautiful Zen doodle images. Hopefully, the examples will inspire you to start drawing your own Zen doodle images.

Chapter 1 – How to Draw a Zen Doodle Violin

Violin seems as an instrument that is easy to draw. You only need a couple of hand movements to draw its outline. However, just doing that will not look so amazing as it would if you added ornaments. This can be done with Zen doodle drawing technique which we are going to explain bellow. Follow our simple instructions for drawing Zen doodle violin, but don't forget to give a touch of your personality to the drawing. After all, the Zen doodle art is about finding the artist within.

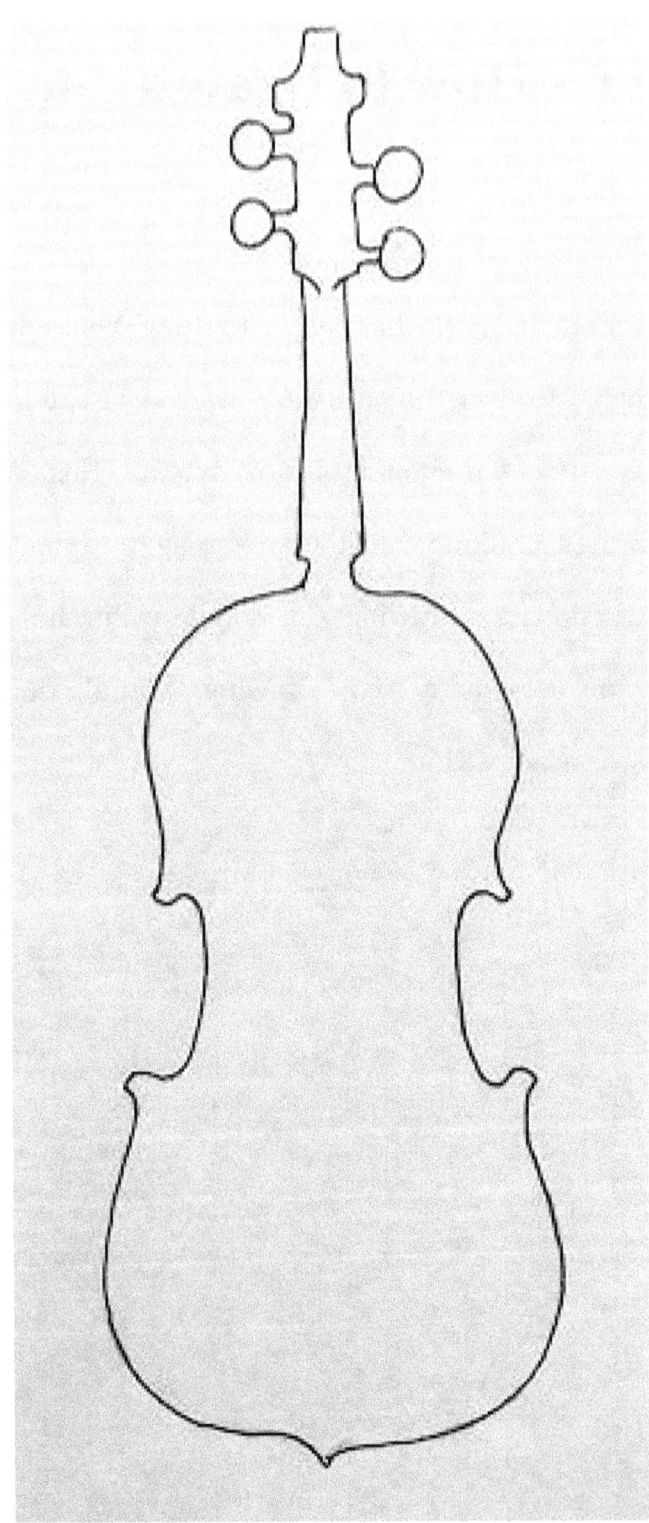

After drawing the basic violin shape, it's time to start with Zen doodling. The first step is to start from the top, where the violin peg box is. Our advice is to start with Zen doodles by drawing spiral shapes inside of the top left peg. For the other three you can use other shapes like stars, spots, and circles.

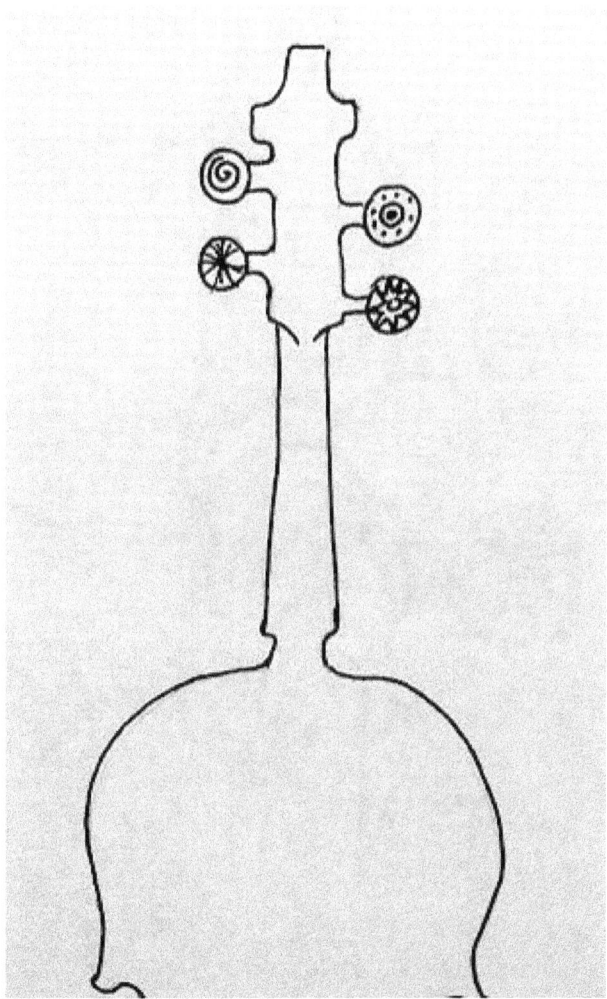

Once you're done with the pegs, your hand and mind will be ready to continue drawing. Now it's time to do the whole peg box. Cover it with shell-like doodles by drawing semicircular lines.

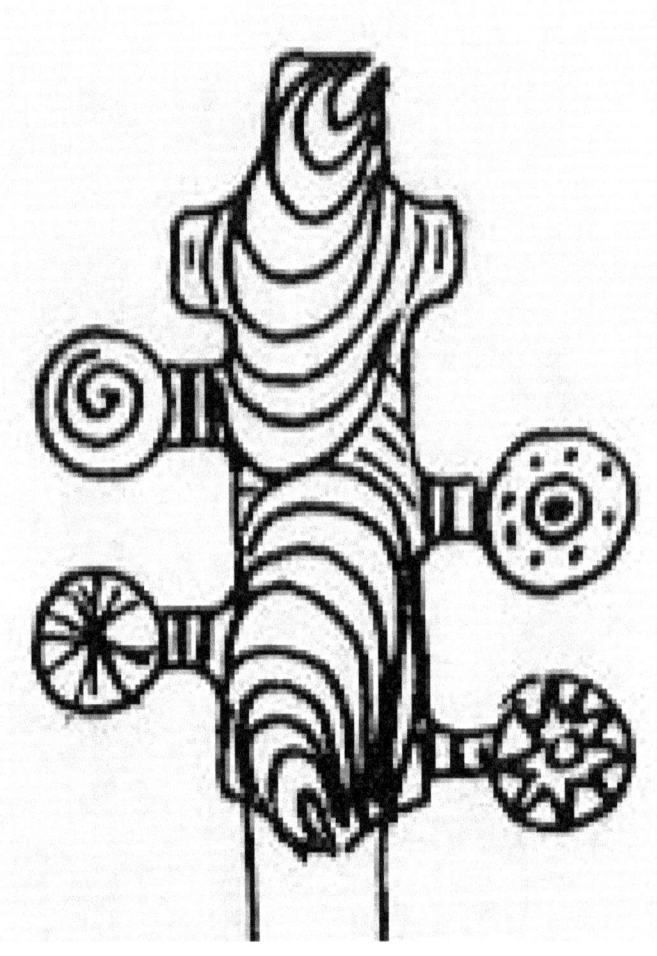

Keep on doodling along the neck line of the violin, moving with your doodles toward the lower part of the instrument. The best way to separate the pegbox from the rest of the violin is by drawing doodles of different designs. You used semicircular lines for filling the pegbox part, so for the neck of the violin, we recommend using zigzag and straight lines, alternately.

In fact, the best would be to use a thick bold line, then a thin one and finally a zigzag line. Keep on doing these patterns all the way down, until you reach the body of the violin.

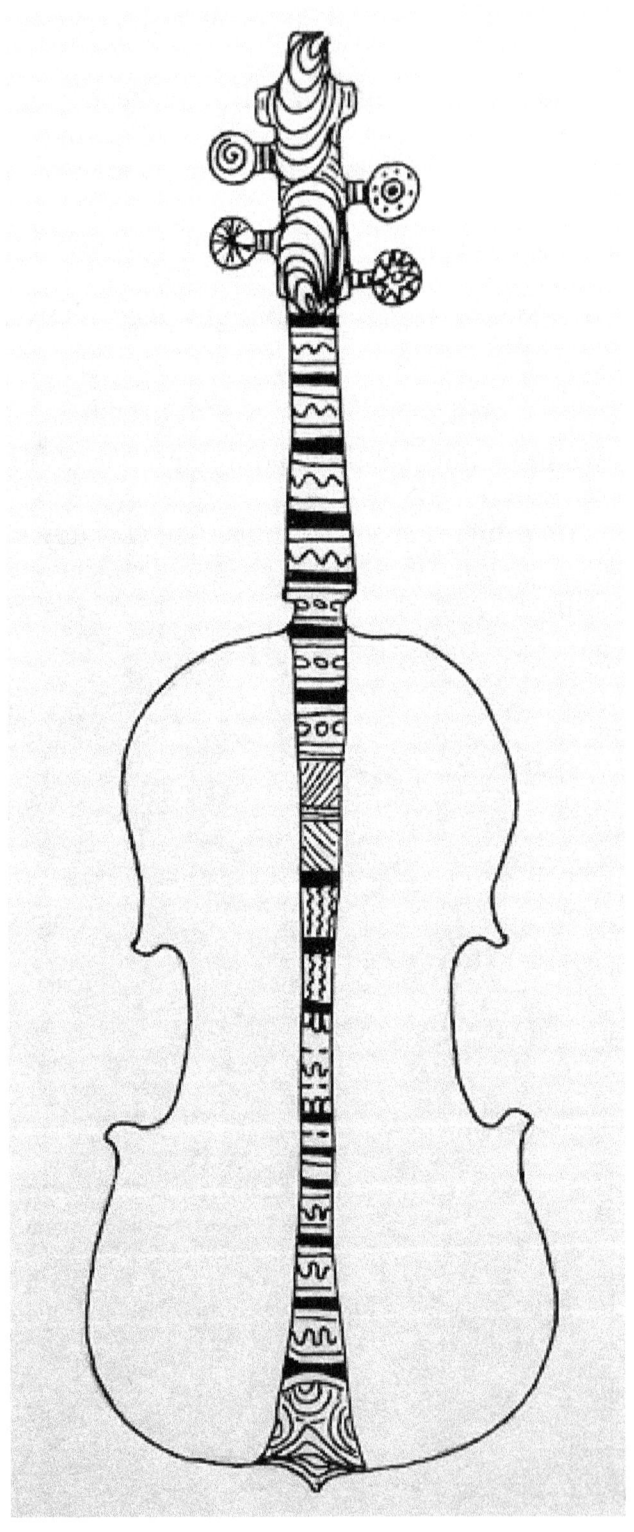

The time has come for drawing the patterns on the body of the violin. By this point you already have doodles separating the violin's body in two parts, so you need to draw different patterns now. On the left side, our advice is to draw lines that would resemble leaves. The other half of the instrument should be reserved for circles and stars.

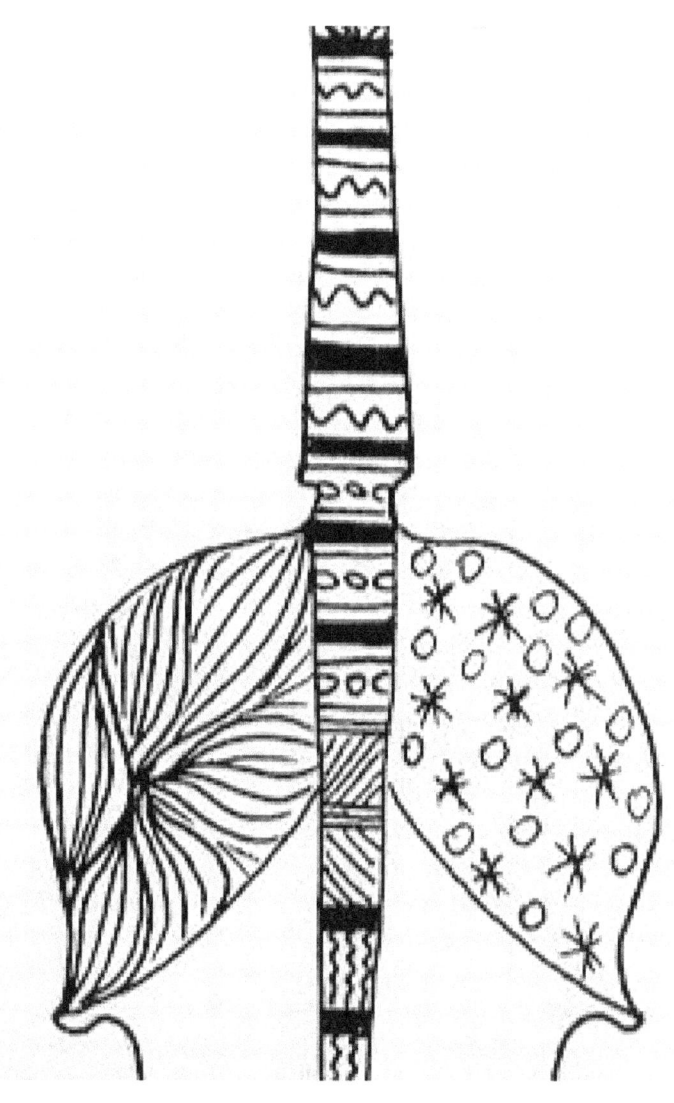

If you separate each side of the body of the violin in three parts, the next step is to do the middle. On the left, the top resembles leaves or buds, so the middle part should be something different. Combine round zigzag lines, longwise with circles. The zigzag lines should be done as if you were drawing a snake or a worm.

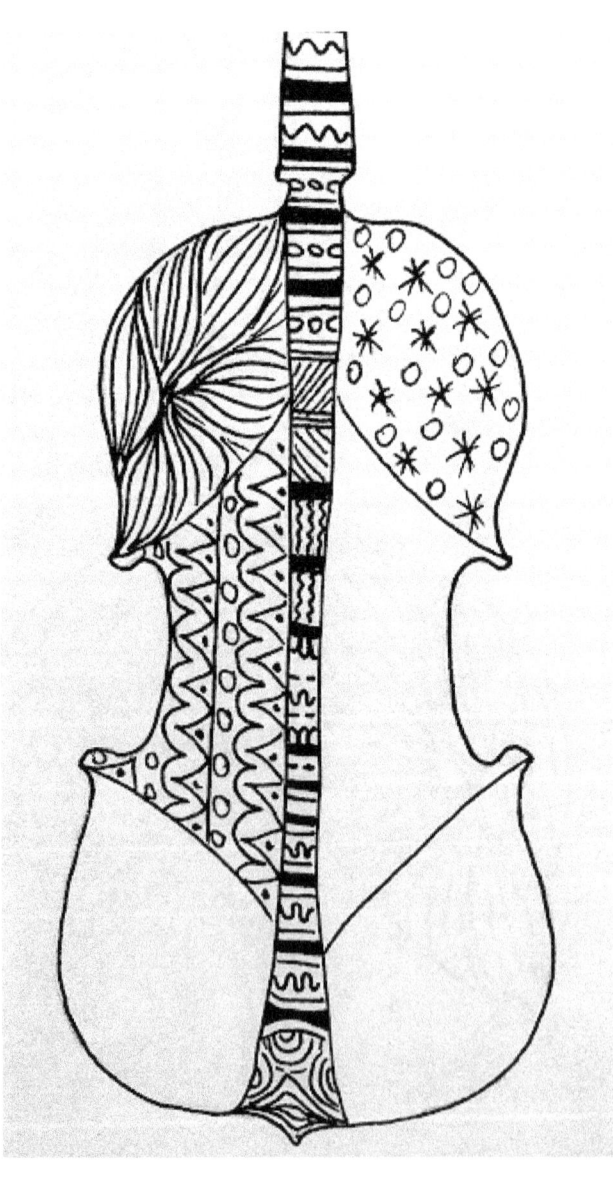

The middle part of the right half should also have its separate design. Our advice is to go with lines and circles, like you were doing a tic-tac-toe.

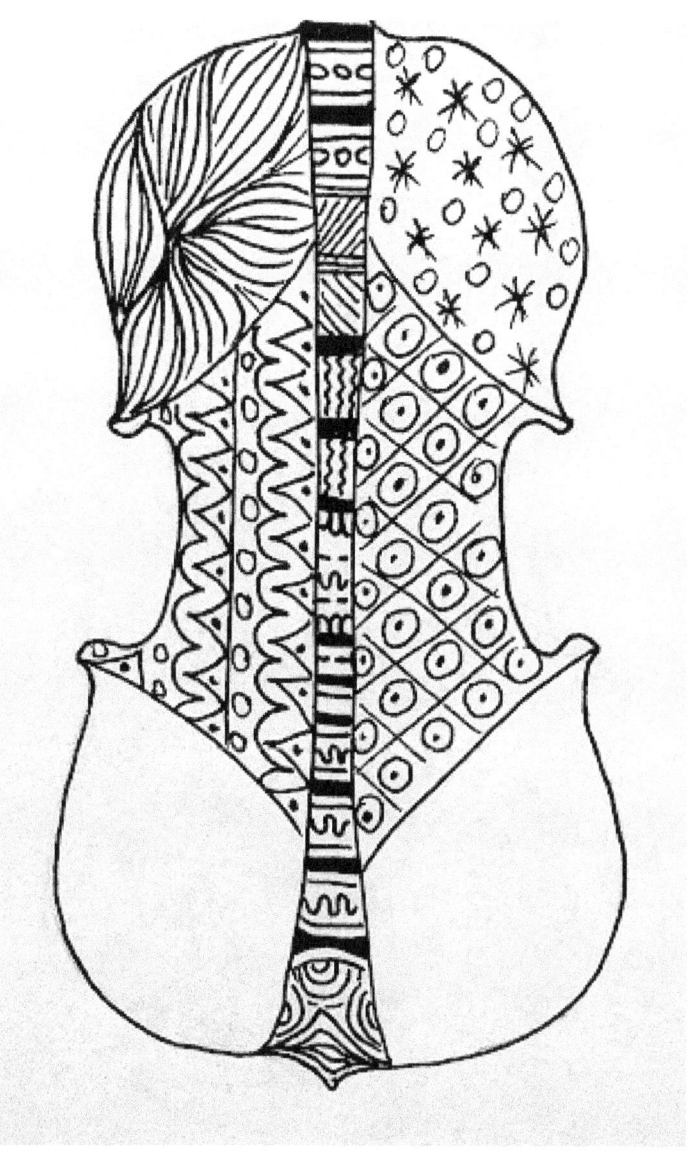

For the two bottom parts of the violin, you should use doodles that are bigger. Think of sea creatures for inspiration. In this example, you'll see lines resembling see dragons and clams.

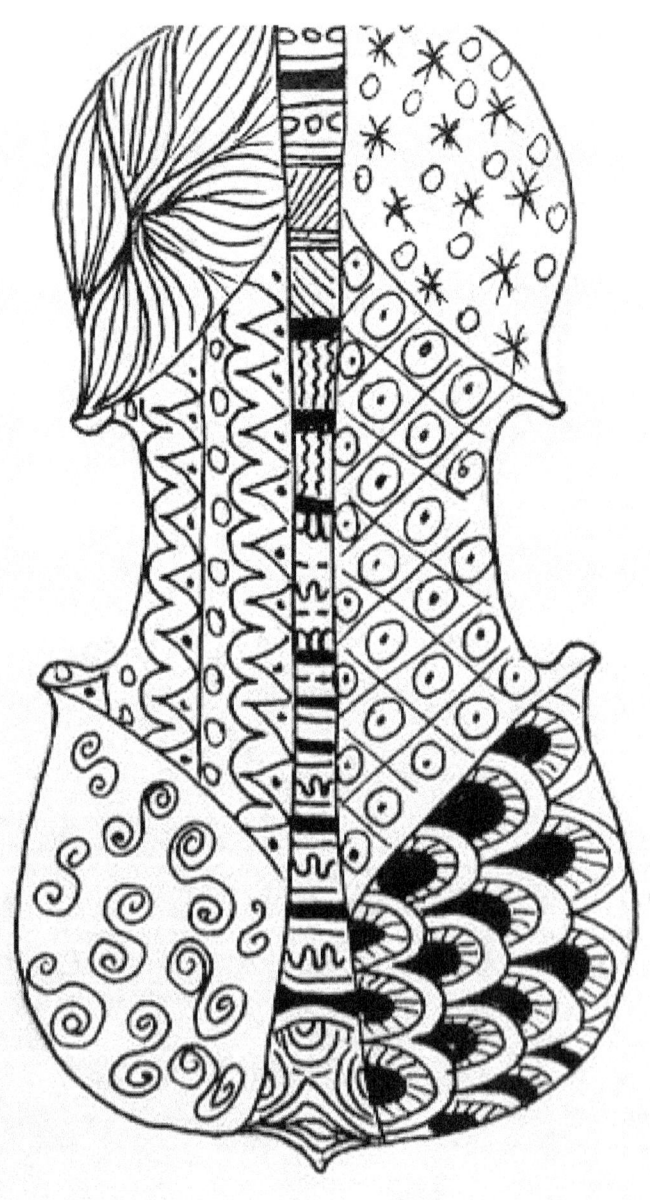

And that's it – your Zen doodle violin is complete!

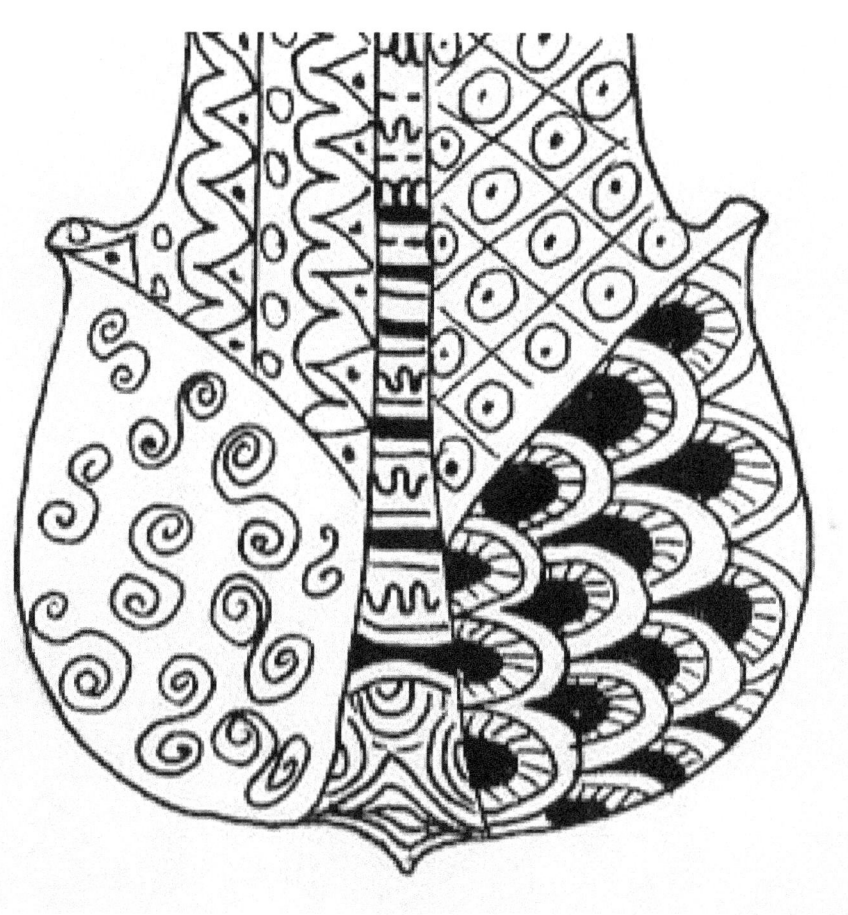

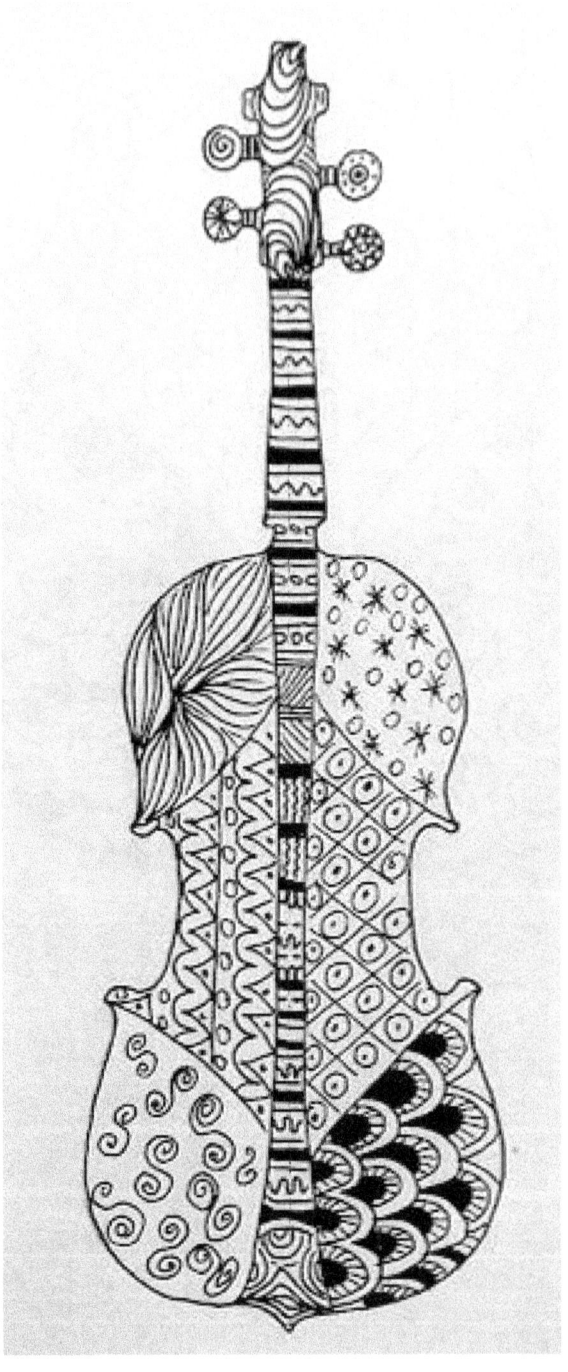

Chapter 2 – How to Draw a Zen Doodle Vase?

Drawing a simple vase might sound like an easy, but boring thing. However, if you ornament it with Zen doodles, you can create a beautiful drawing. See the examples below to see how we did it. Again, remember that all of these images are simply suggestions and that you should come up with your own patterns for doodles. Let your mind free and release the artist within. Once you do that, you'll see that you are able to produce some wonderful drawings.

After drawing the basic shapes of a vase, it's time to separate several areas, in which you'll draw doodles. We decided to do three leaves on the left side, so we could make the design more interesting. Speaking of doodles, we started from the top, drawing circles and rectangulars.

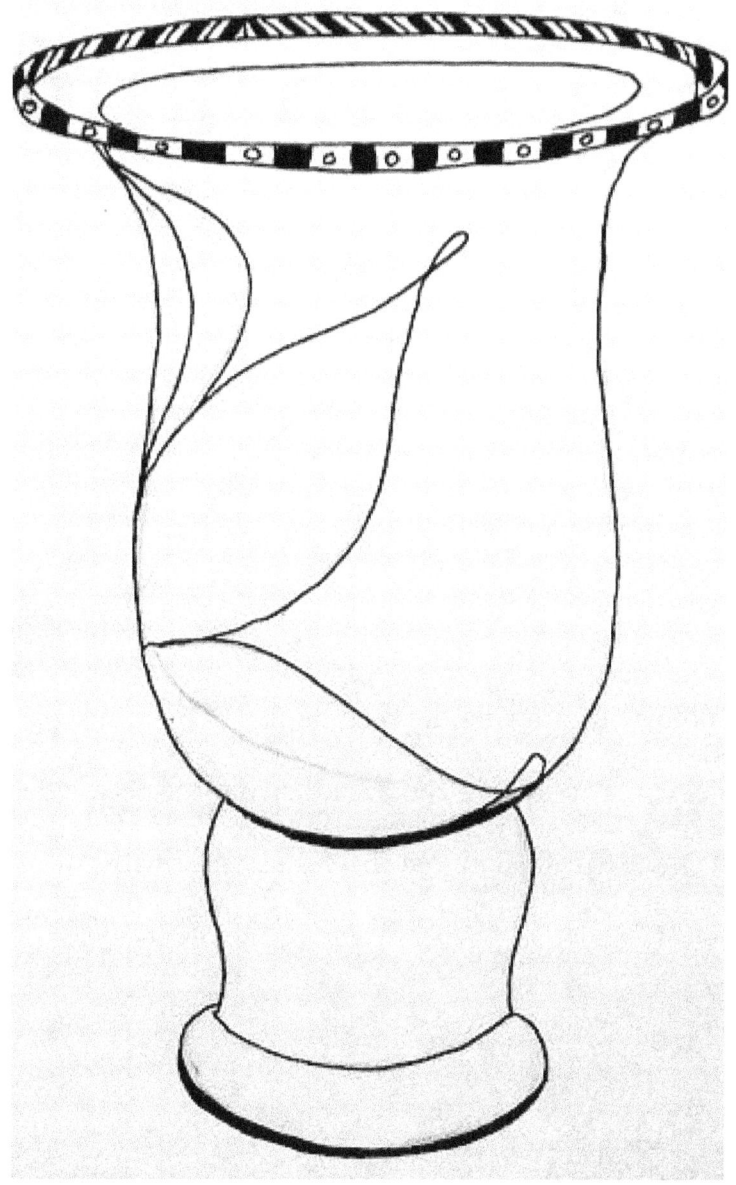

If you take a look at the top of the vase, you can see that we used lines and rectangular for the middle and the inner part.

Once you're done with drawing the rectangular in the inner part of the vase, it's time to color that part. Fill the area, leaving the rectangles blank. This way, you will create the illusion that the vase is filled with soil.

Once you are done with the top of the vase, you should proceed to drawing doodles inside of the flower areas on the left side of the drawing. Our advice is to draw semicircular lines in one of the three areas.

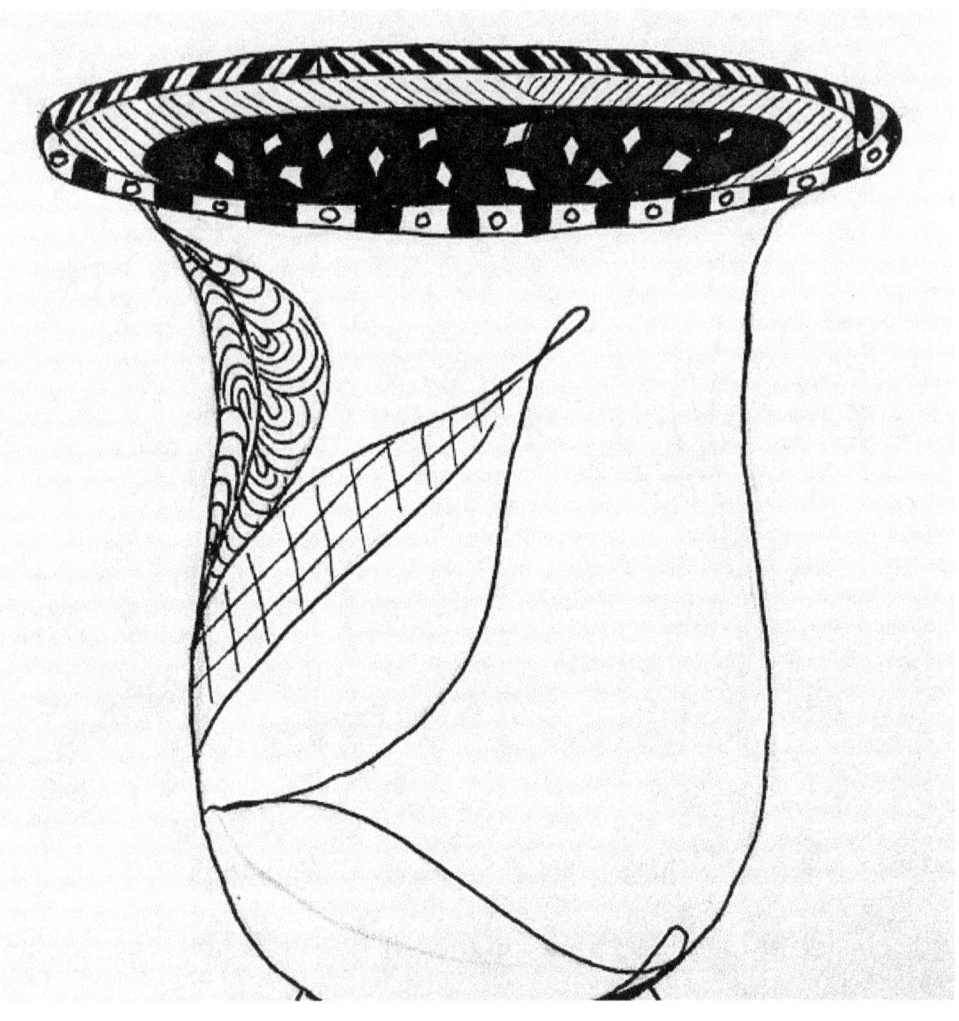

In the second area, you can draw circles and flowers, while in the bottom, your patterns could be zigzag lines.

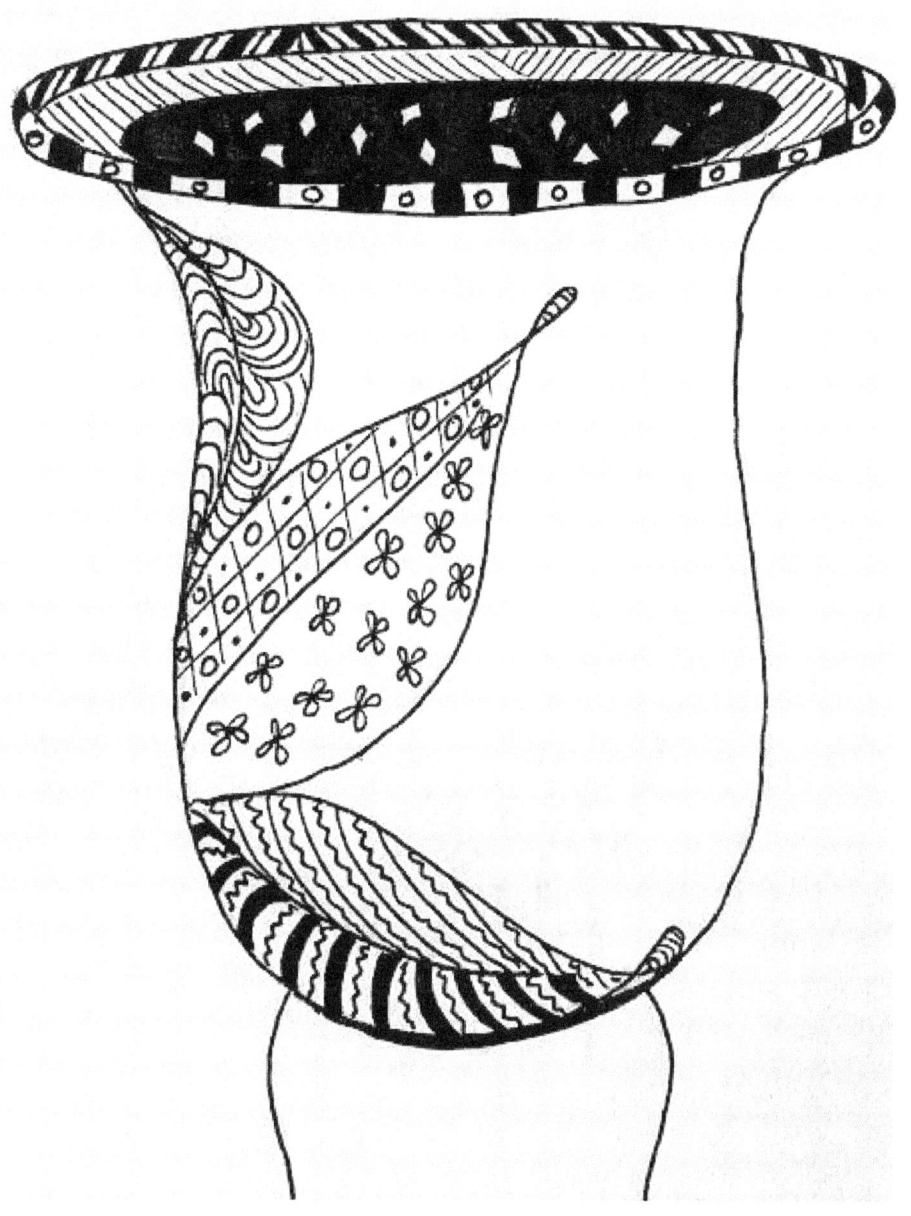

At this point, you have a large empty are at the right of the vase. You can draw four big snowflakes here. You can add a few crosses on top and left from it.

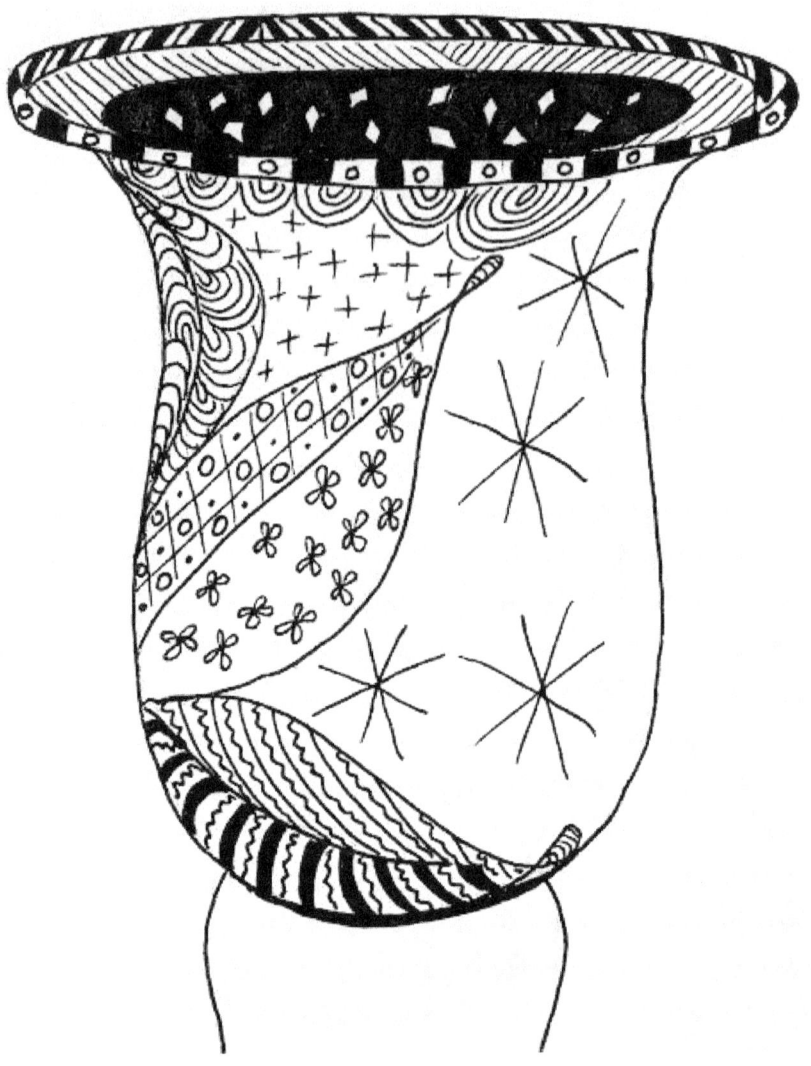

Now, the upper part of the vase is done. You need to add doodles on the base part as well.

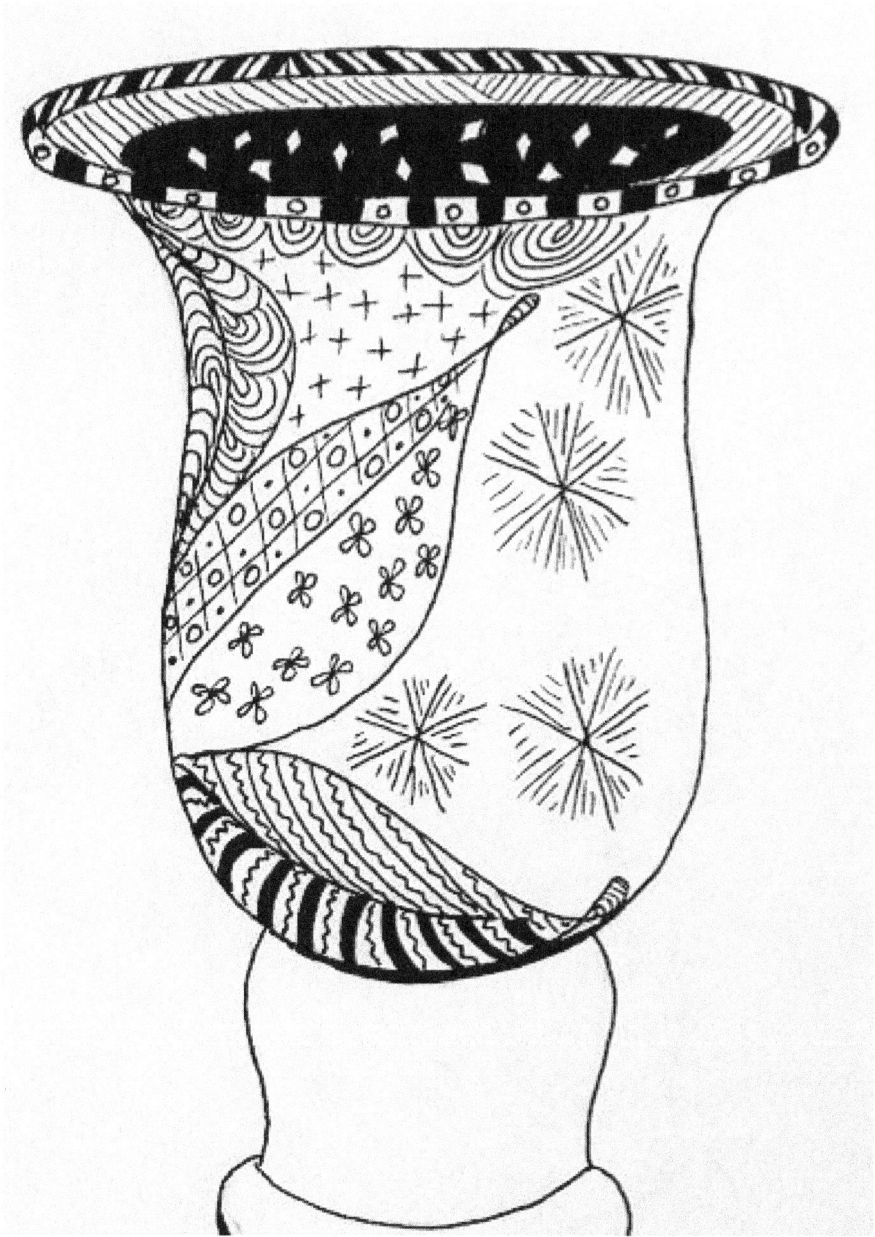

We felt the best design for the base of the vase is a combination of flowers, spiral lines and regular straight lines.

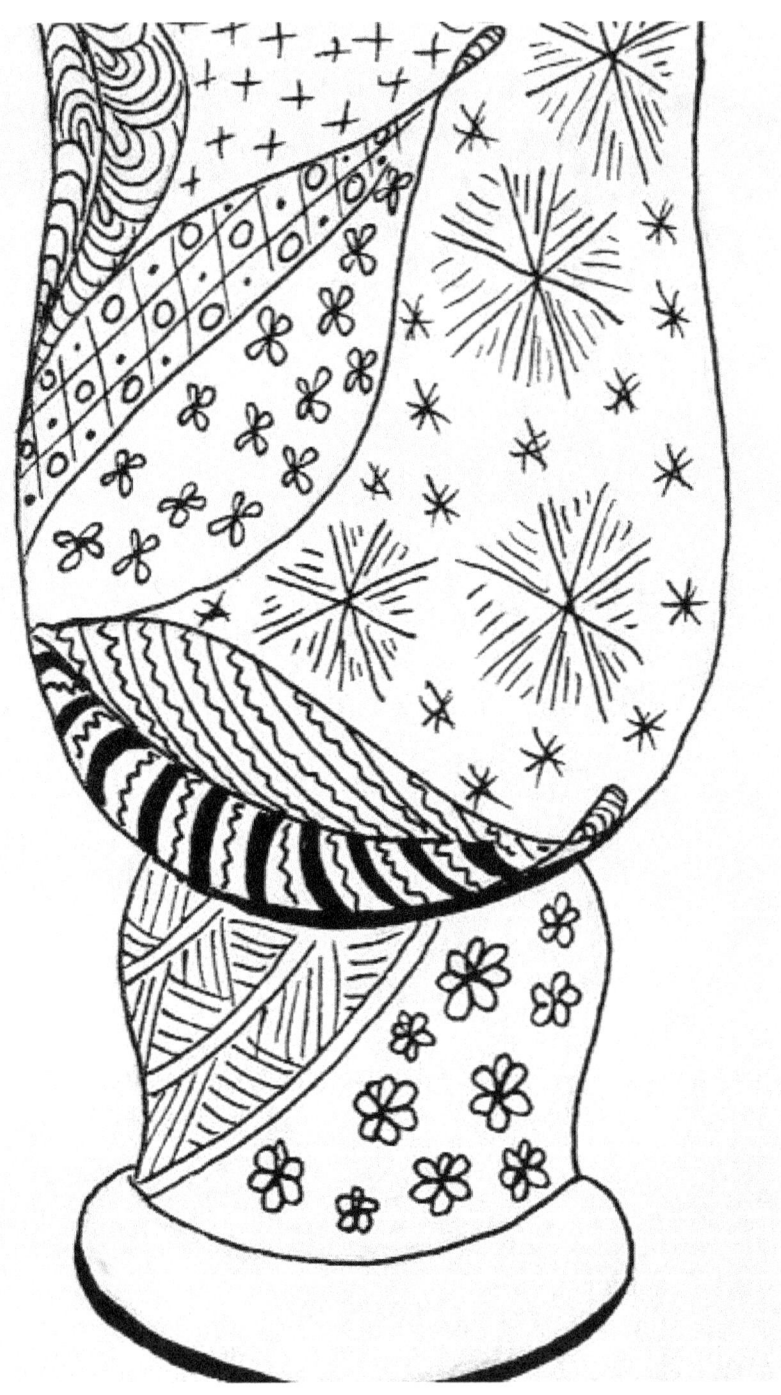

The last image shows you how your Zen doodle vase should look like.

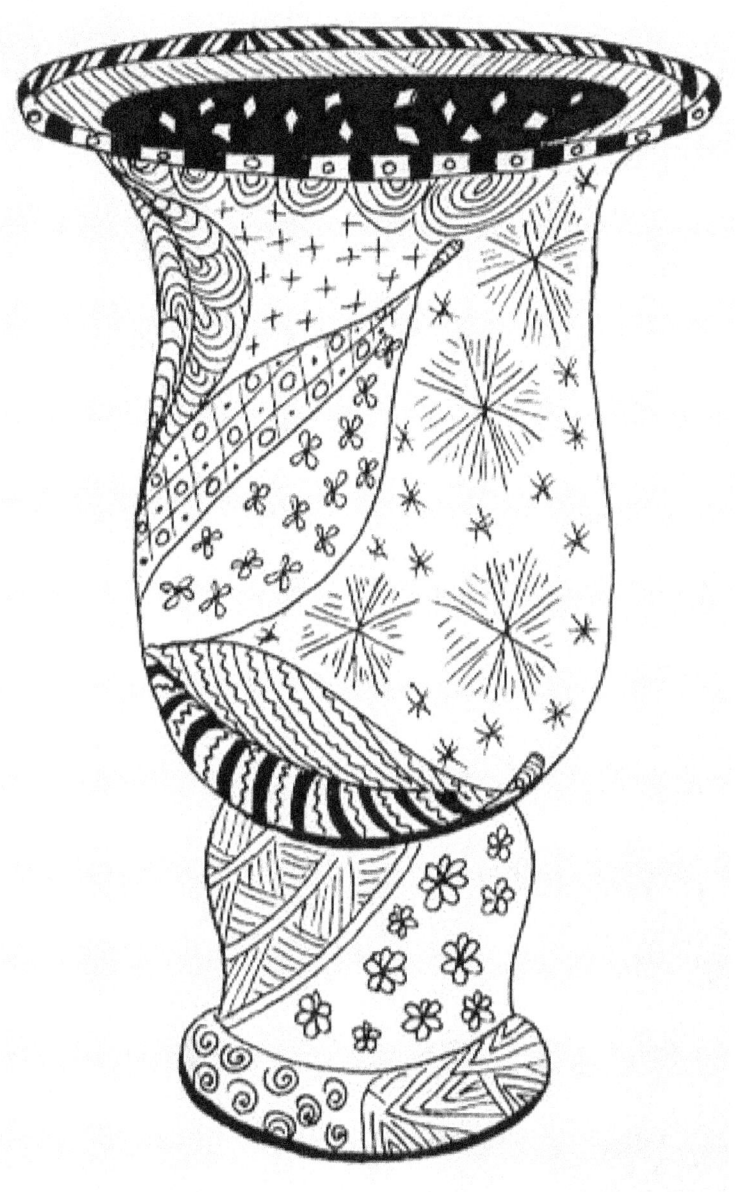

Chapter 3 – Zen Doodle Techniques for Drawing a Young Girl

Maybe you already know how to draw a beautiful girl, but you'll be stunned when you see how amazing the image can look if you add certain details. With Zen doodle drawing technique, you can draw an impressive drawing of a girl. Start by drawing the basic contours of the girl's face, such as head, nose, eyes, etc.

The next step is to bold the lines that make the head contour, hair, eyes, nose and mouth. You can immediately start with Zen doodling by drawing a line of circles instead of the upper lip and one of the eyebrows.

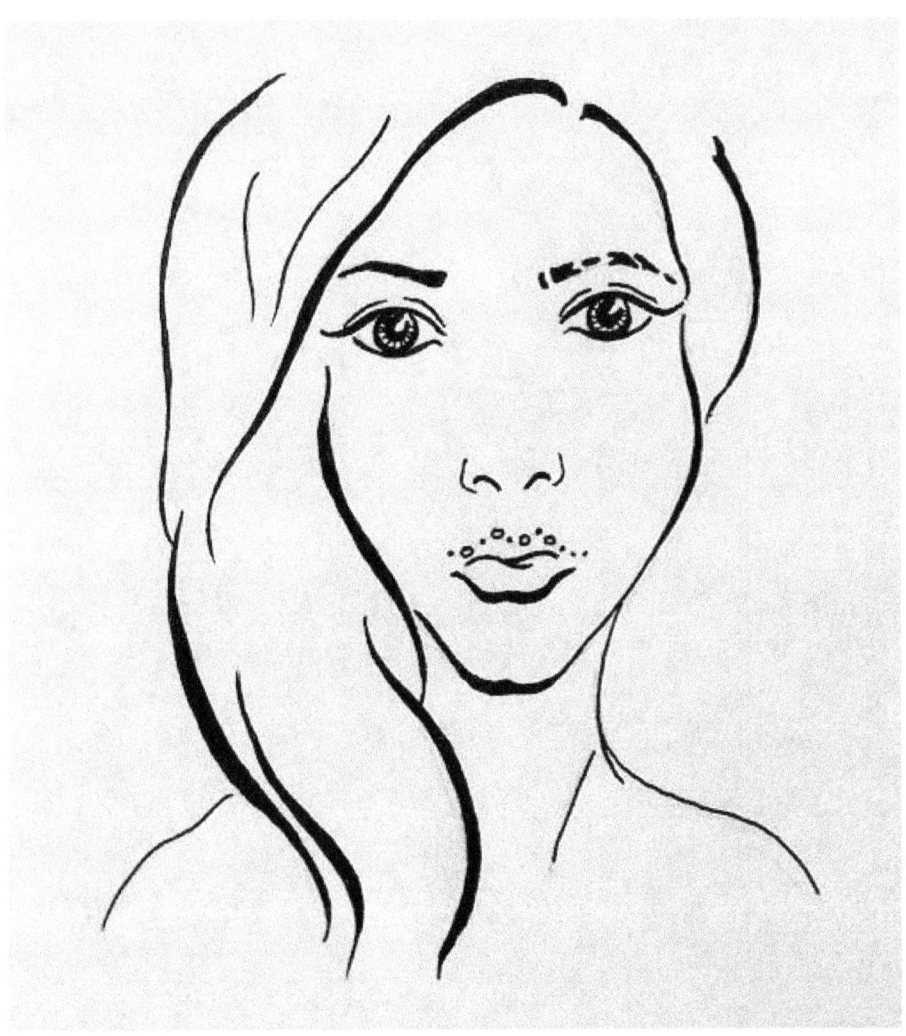

At this point, you should start drawing doodles to make the hair of the girl. Our starting point was the right upper part, just above her left ear. We started by drawing concentrated semicircular lines, so the patter would appear as a sea shell. We did the same with the lower lip. If you want to follow our instructions, you should also start drawing doodles on both of the girl's eyebrows.

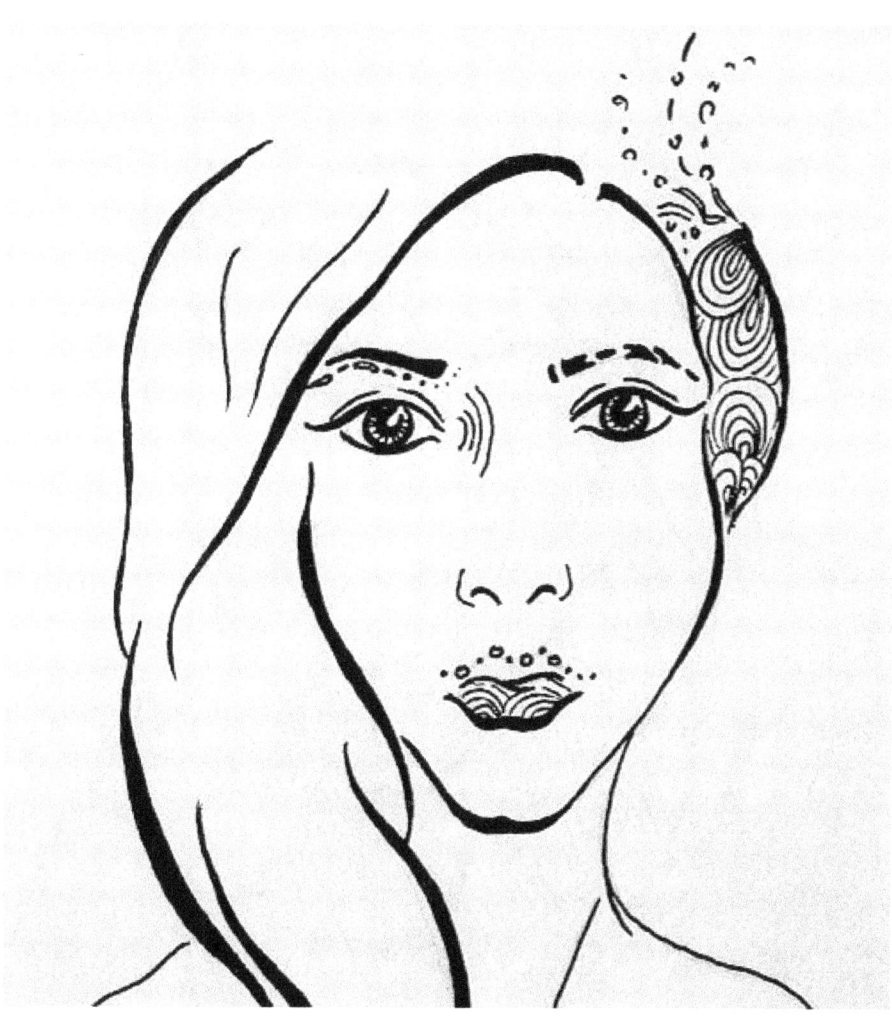

Now, you should do the other end of her hair. Draw snail-like shapes in the lower left area.

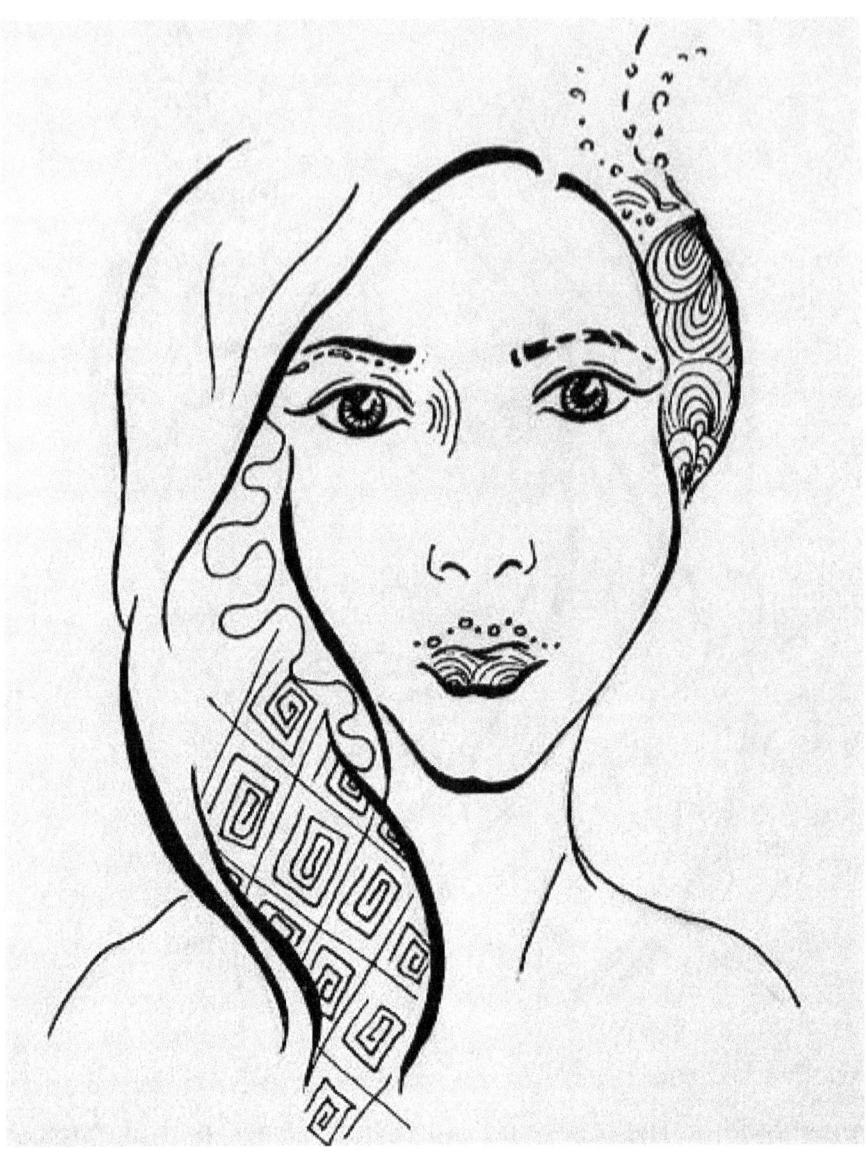

Add a few more patterns, like flowers or curvy lines in the hair area.

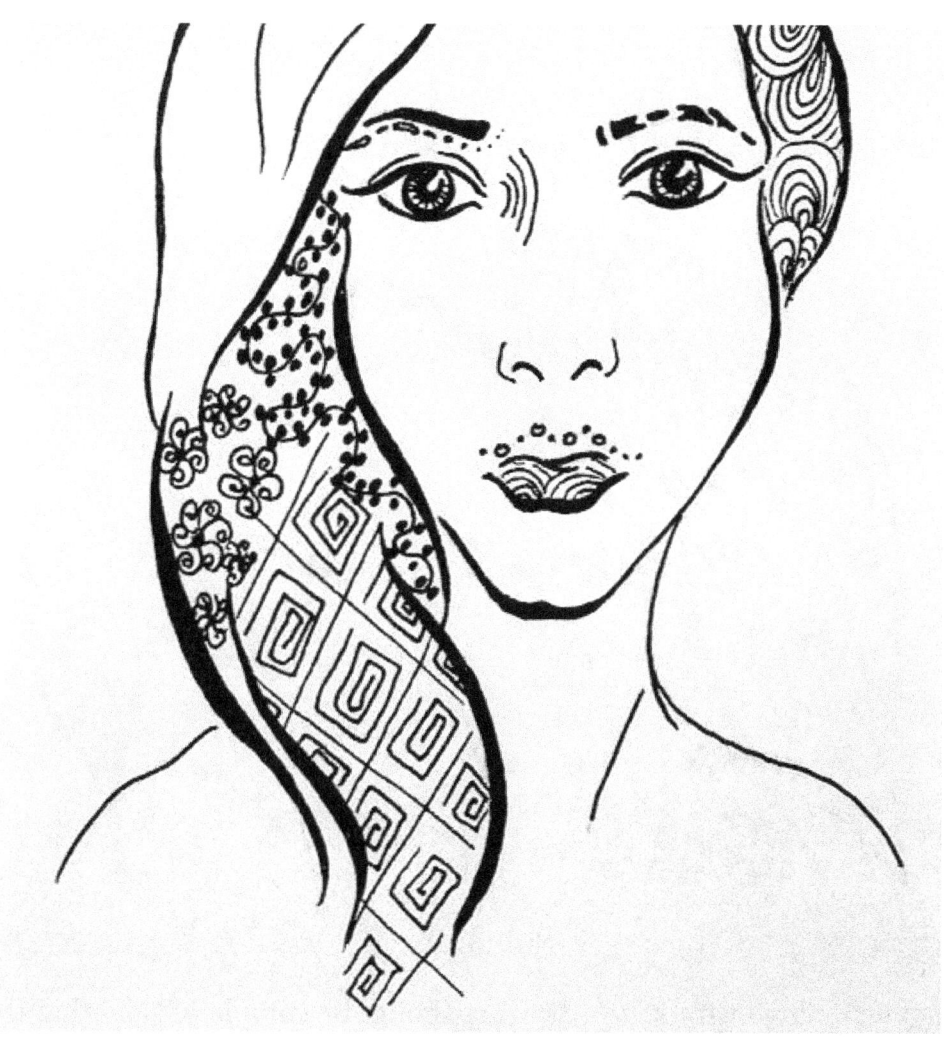

Finish with the hair by adding several different patterns of the doodles. In our example, we used circles, rectangles and leaves.

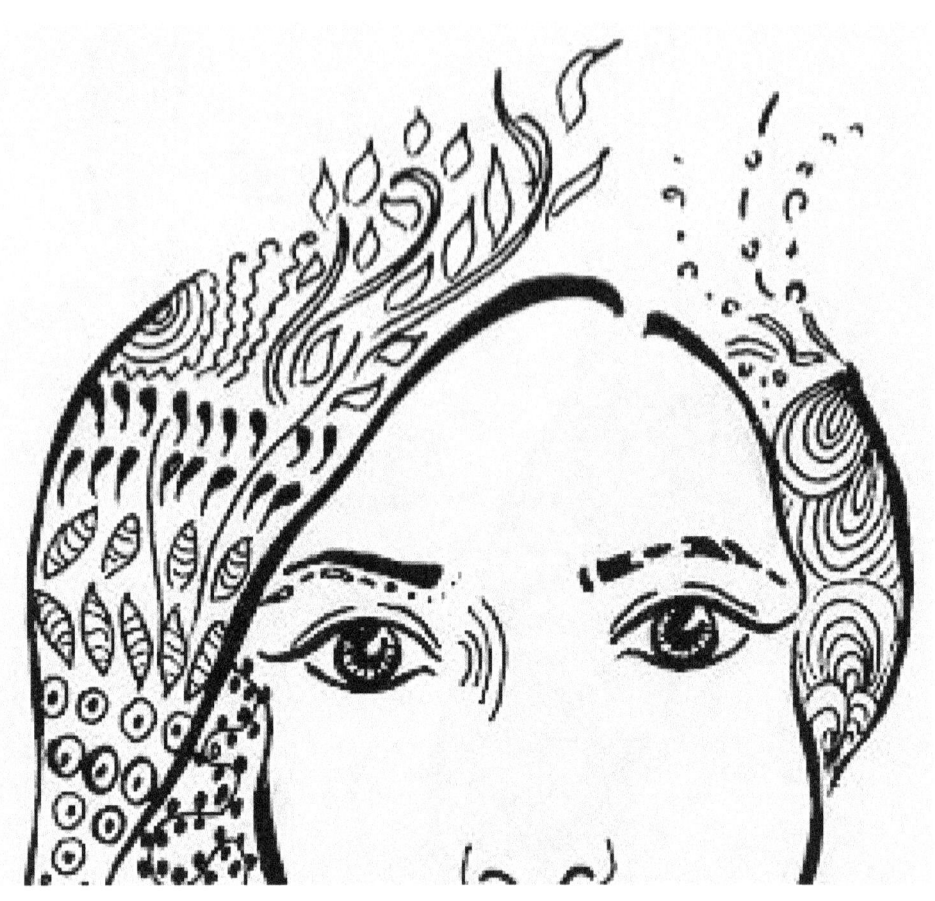

Once you're done with it, the drawing should be complete. Note that this is just our example, which means you can use any kind of doodles you like.

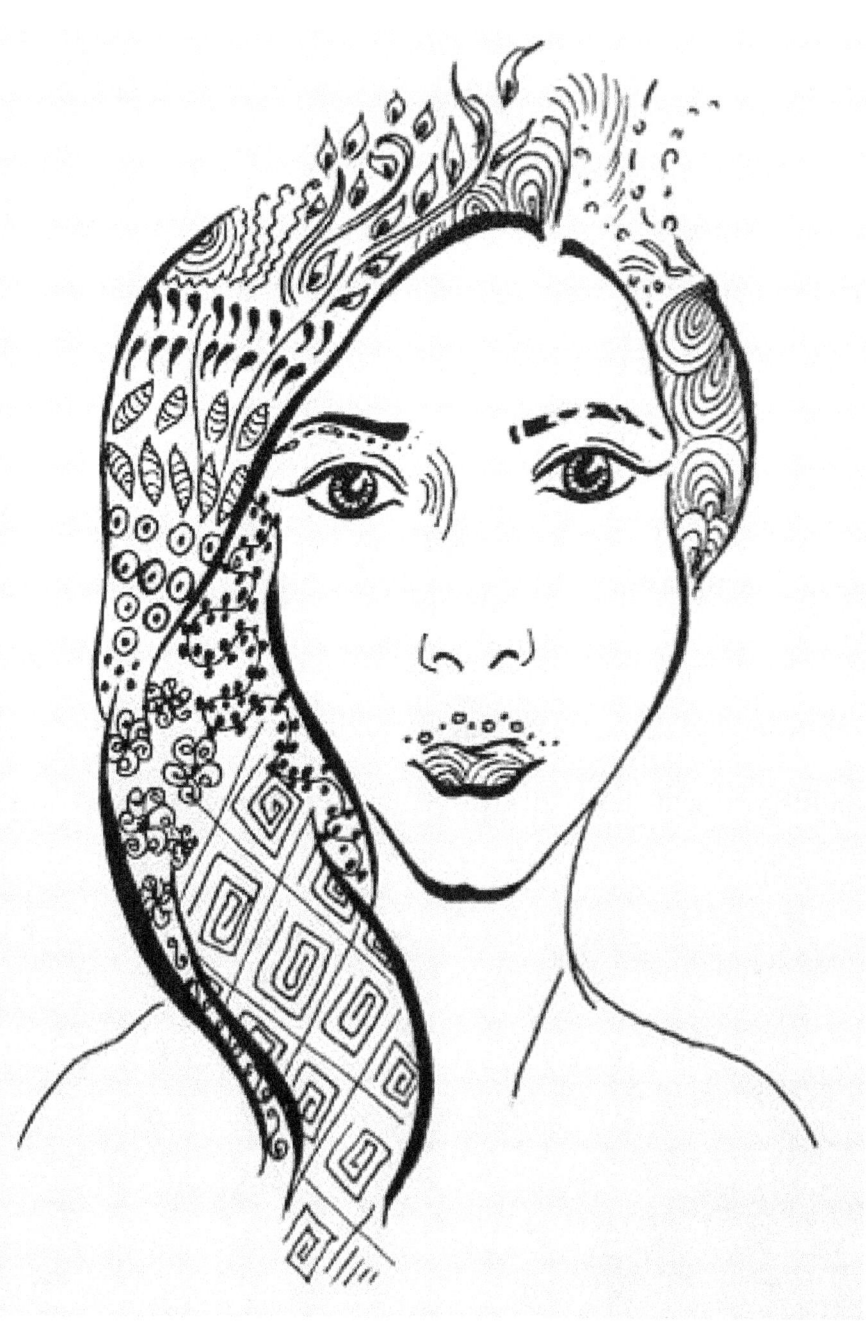

Chapter 4 – How to Draw a Candle with Zen Doodles?

Candle is an object that has been inspiration for artist for centuries, because it produces light. It seems that candles were much more important in the past, but you can bring them back in fashion by drawing interesting drawings with Zen doodle techniques. Below are images that show you how you can do it with ease.

Start drawing by doing the outline of the candle. In just a few hand movements you can draw the whole candle, but don't forget to draw the flame as well.

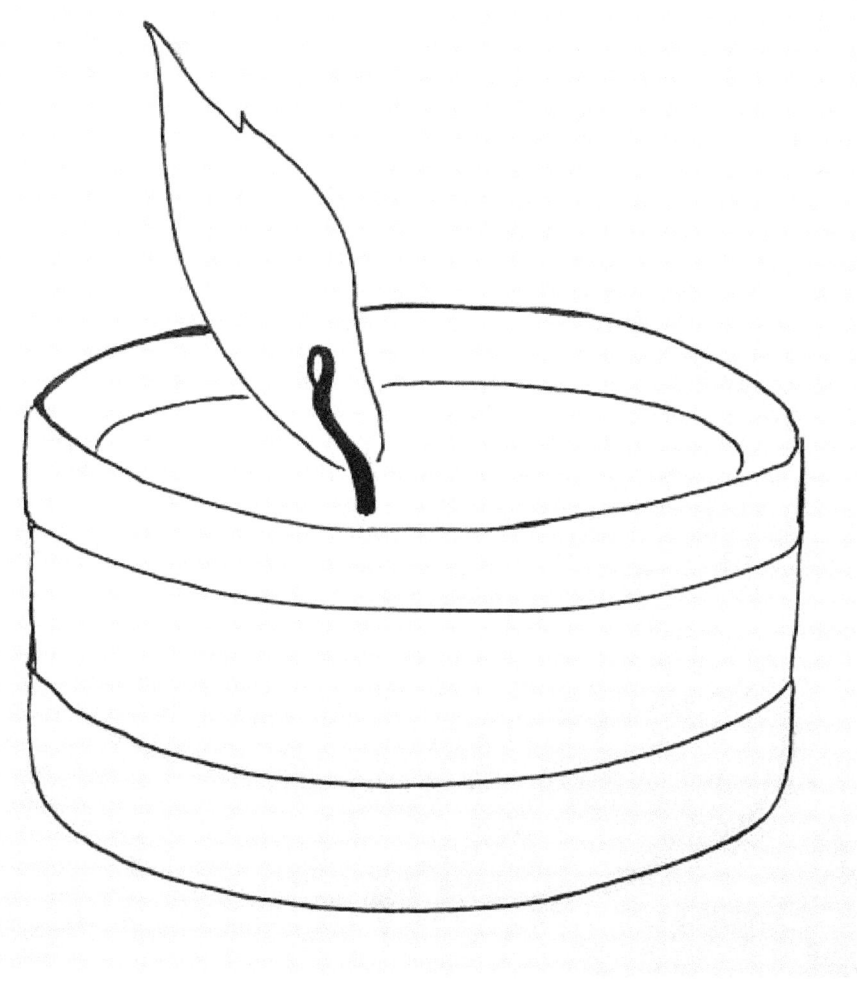

Speaking of candle flame, we decided that it should be our starting point for Zen doodling. We covered the whole area with shapes like snowflakes, which in this case appear like sparks.

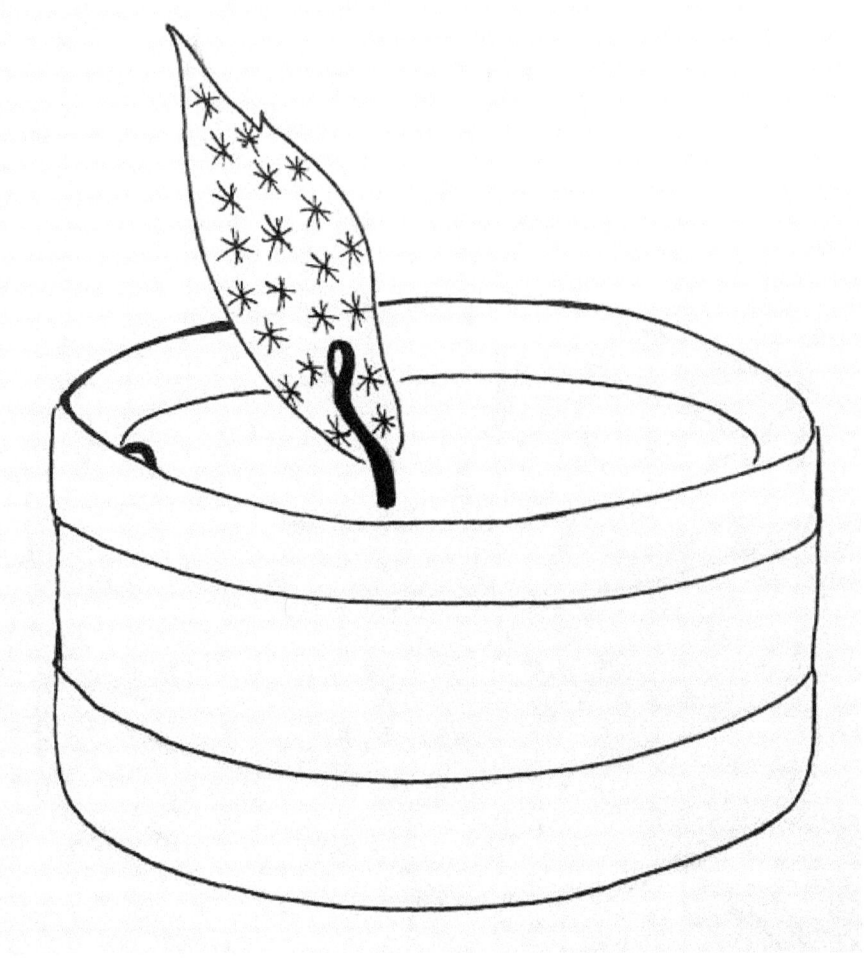

Then we decided to start drawing the inner part of the candle, left to the flame and we advise you to do the same.

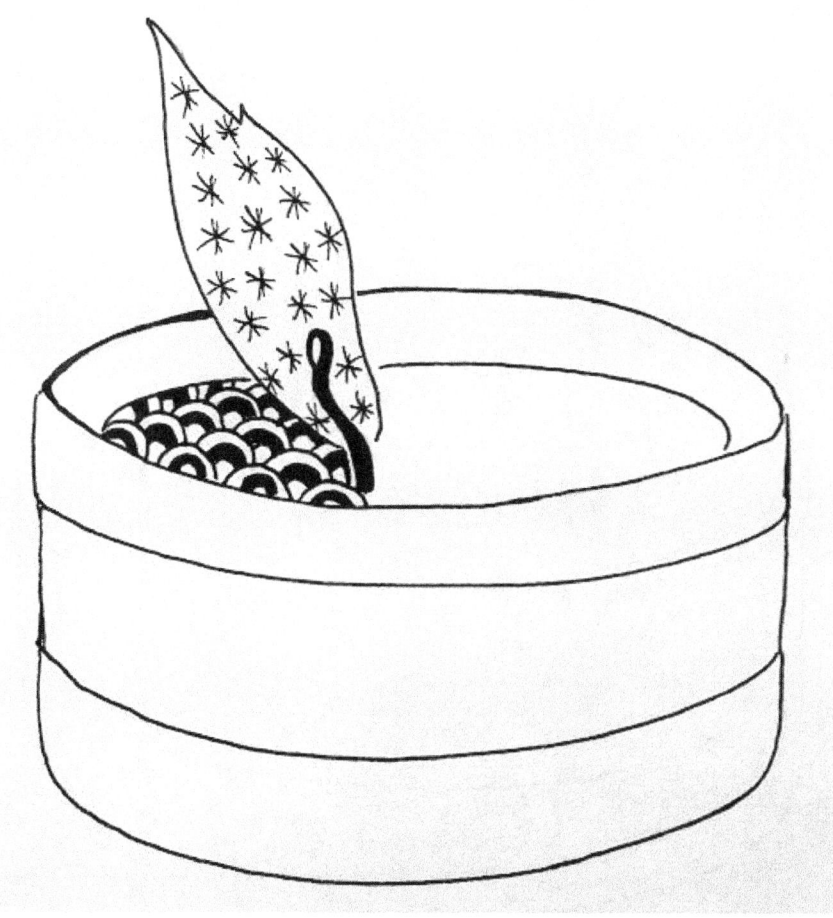

From the left of the flame, we used a patter made of thick semicircular lines.

The right half of the inner part was reserved for triangles.

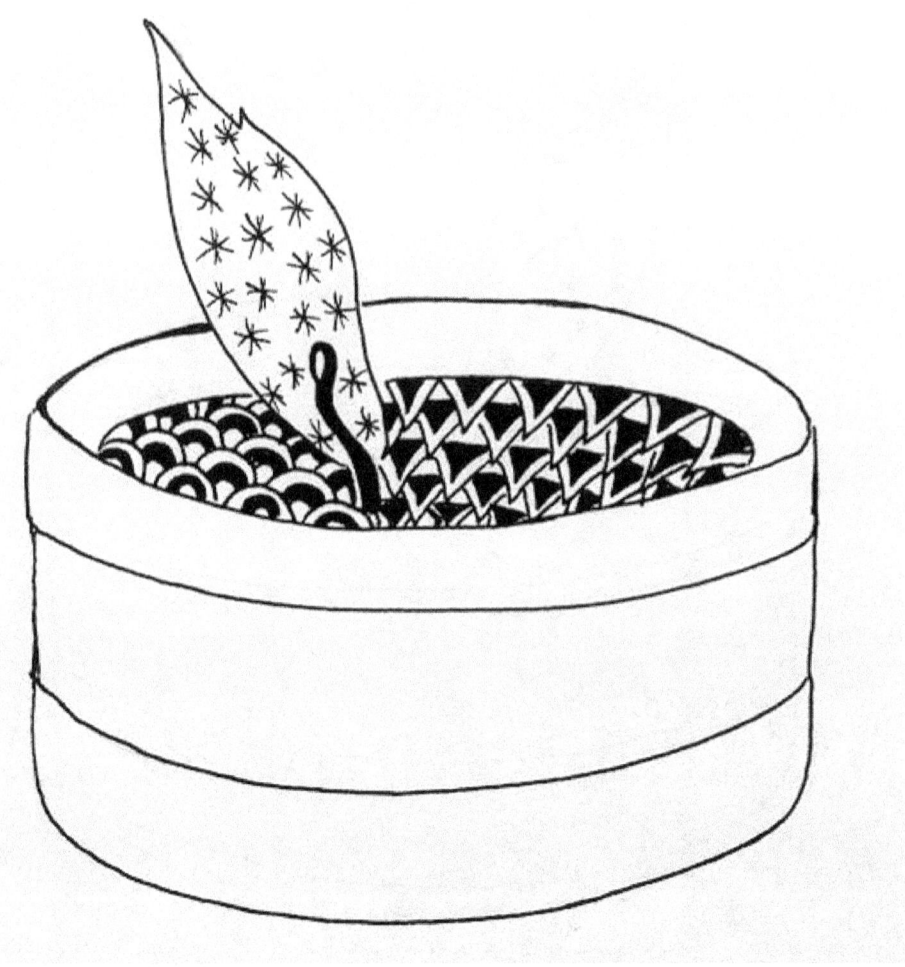

Now, the time is to do the top of the candle jar. For the inner part of this region, we used zigzag and straight lines. For the outer part, we used thick curved lines.

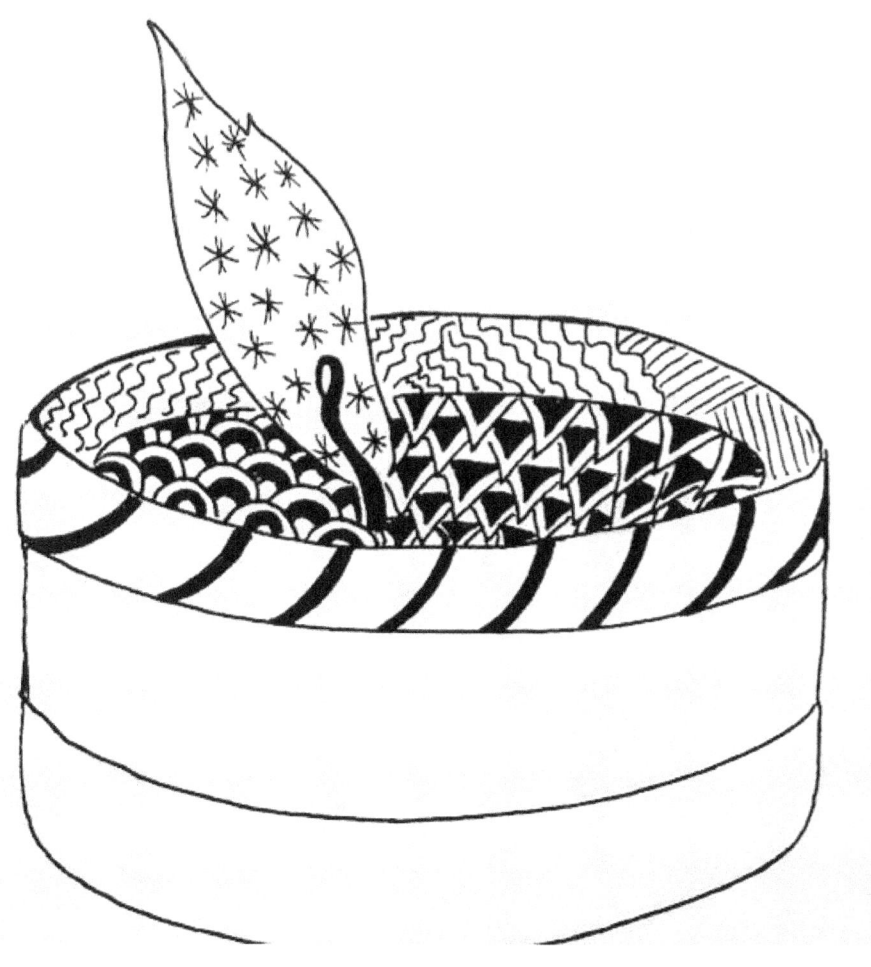

For the middle part, which is the biggest area of the drawing, we advise you to use several different patterns of doodles. Choose anything from straight to curved lines and circles.

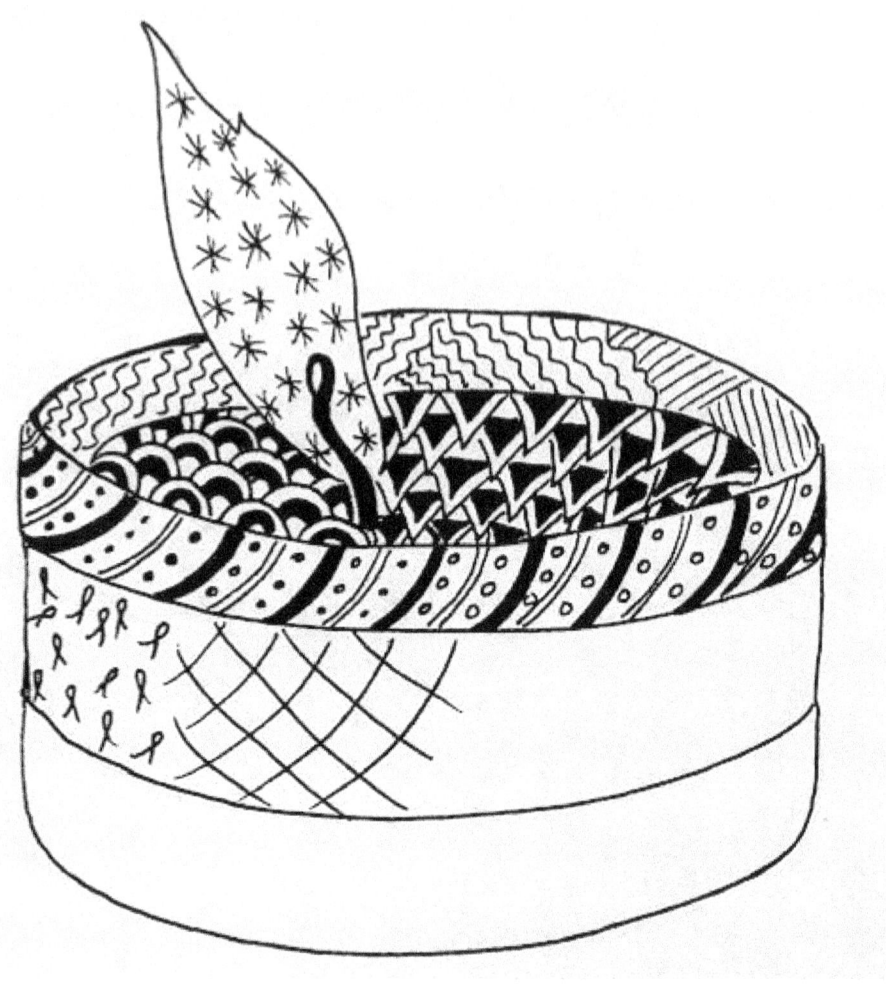

Add also more patterns, which resemble sea shells. You can draw them by drawing concentric semicircular lines.

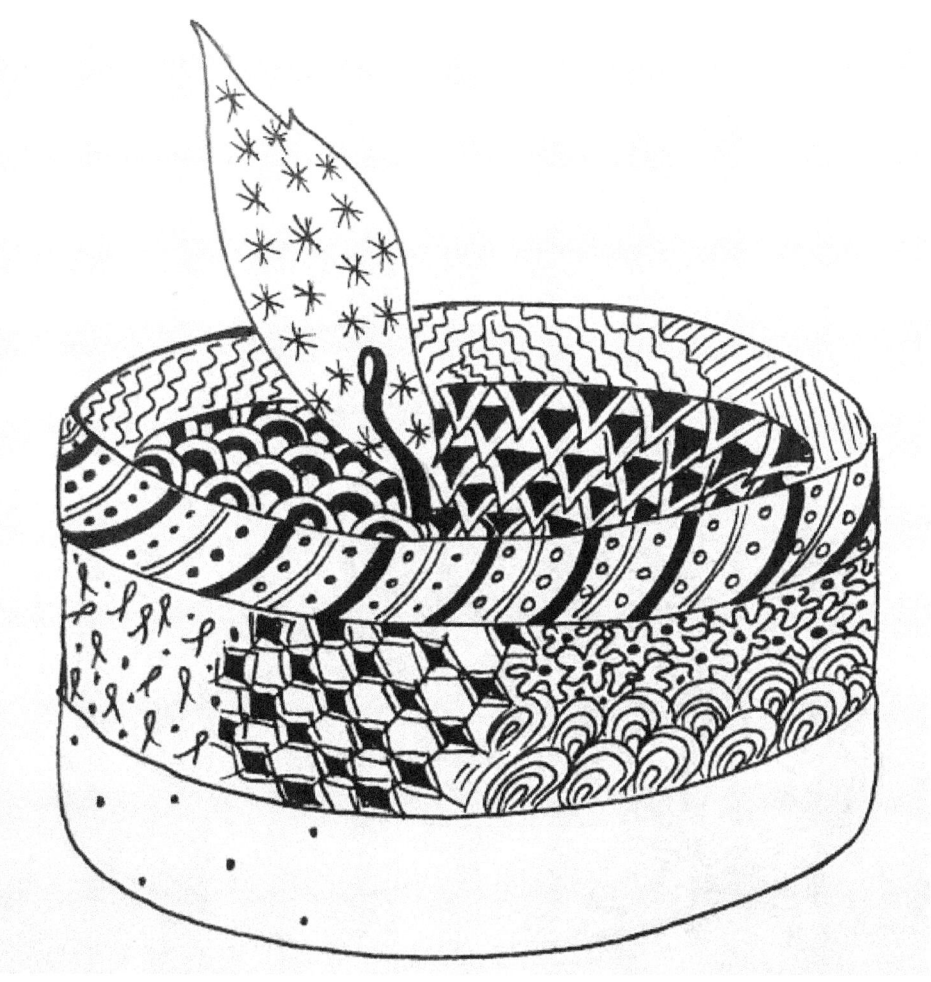

For the bottom part of the object, you can use several patterns. We decided on three. We started with the left part by drawing three big flowers.

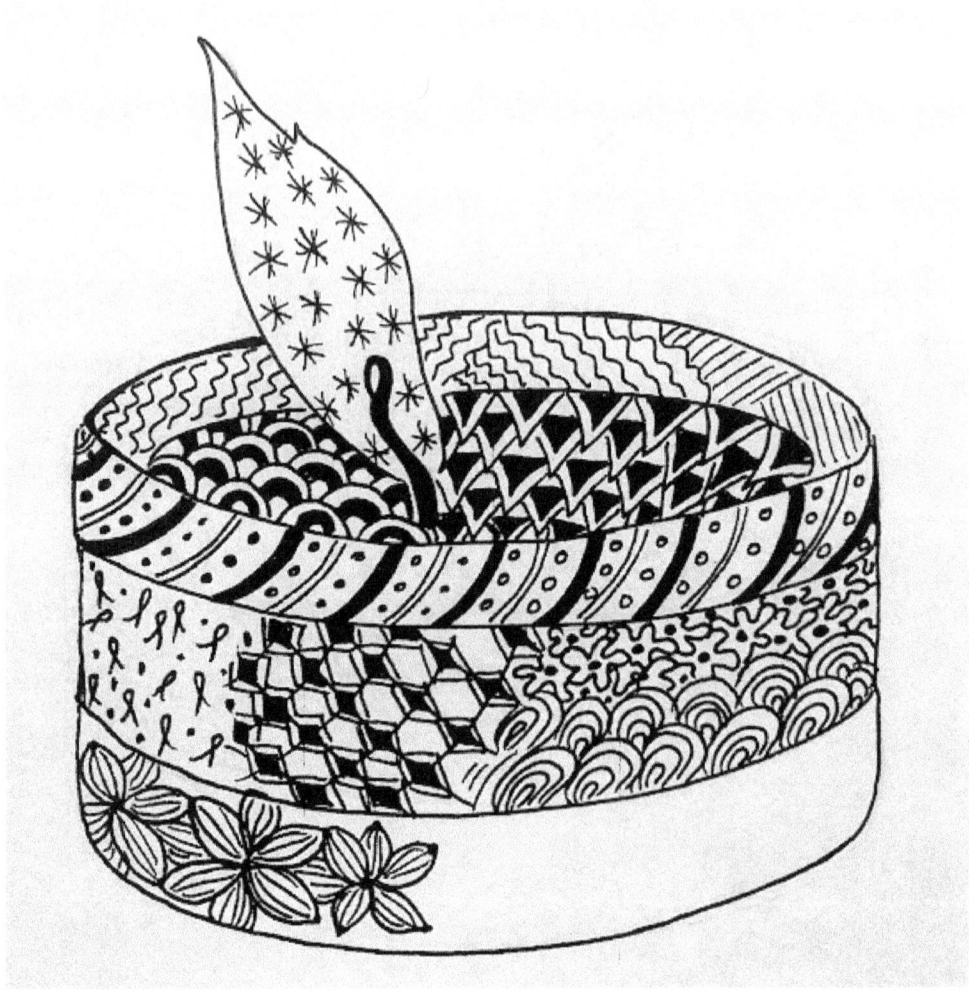

In the middle area, we drew some circles, while in the right corner, we added doodles that resemble shells. Once you do the same, your drawing of a candle should be complete.

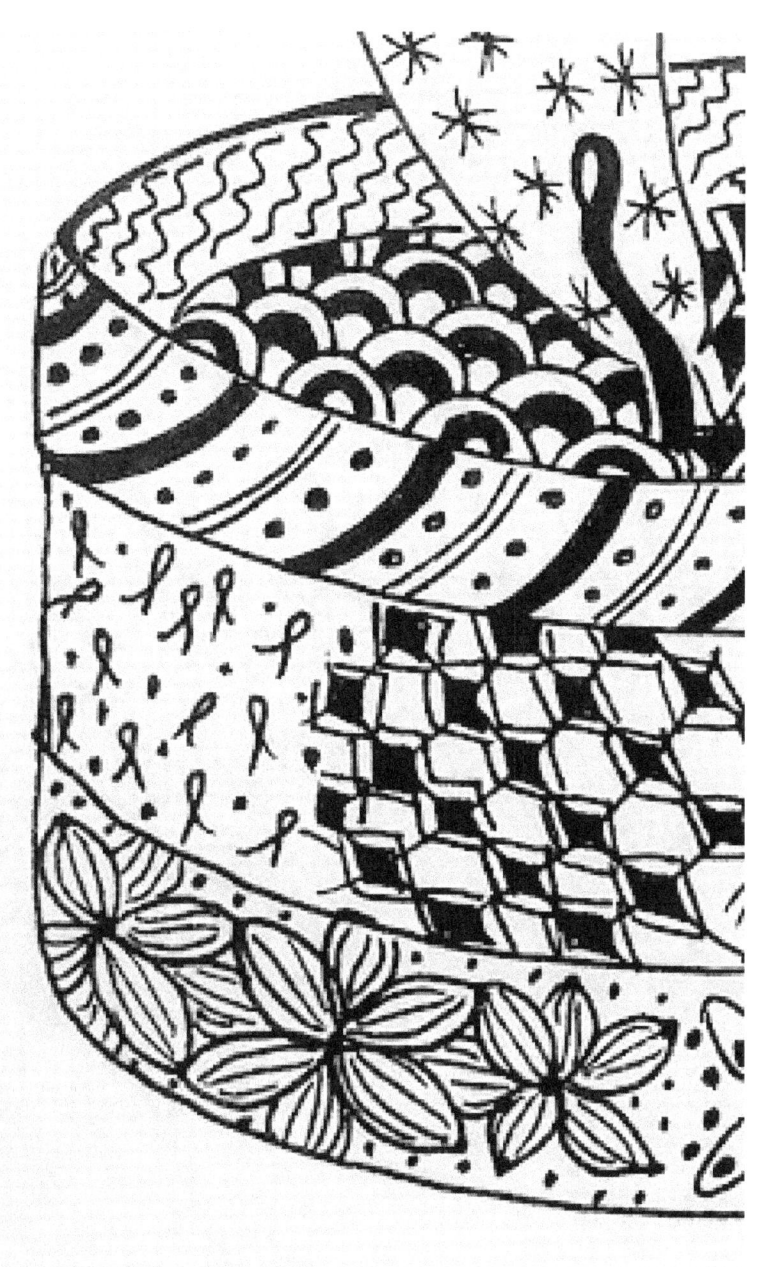

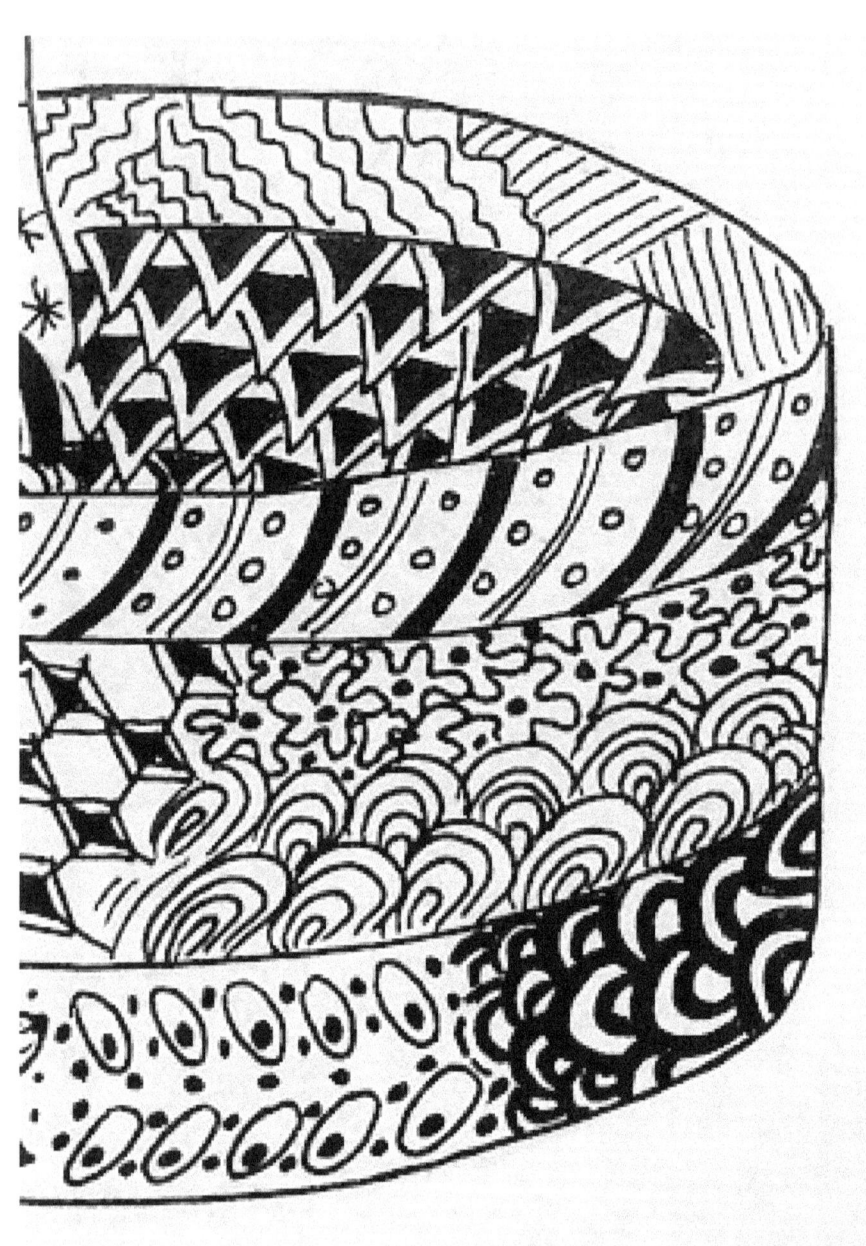

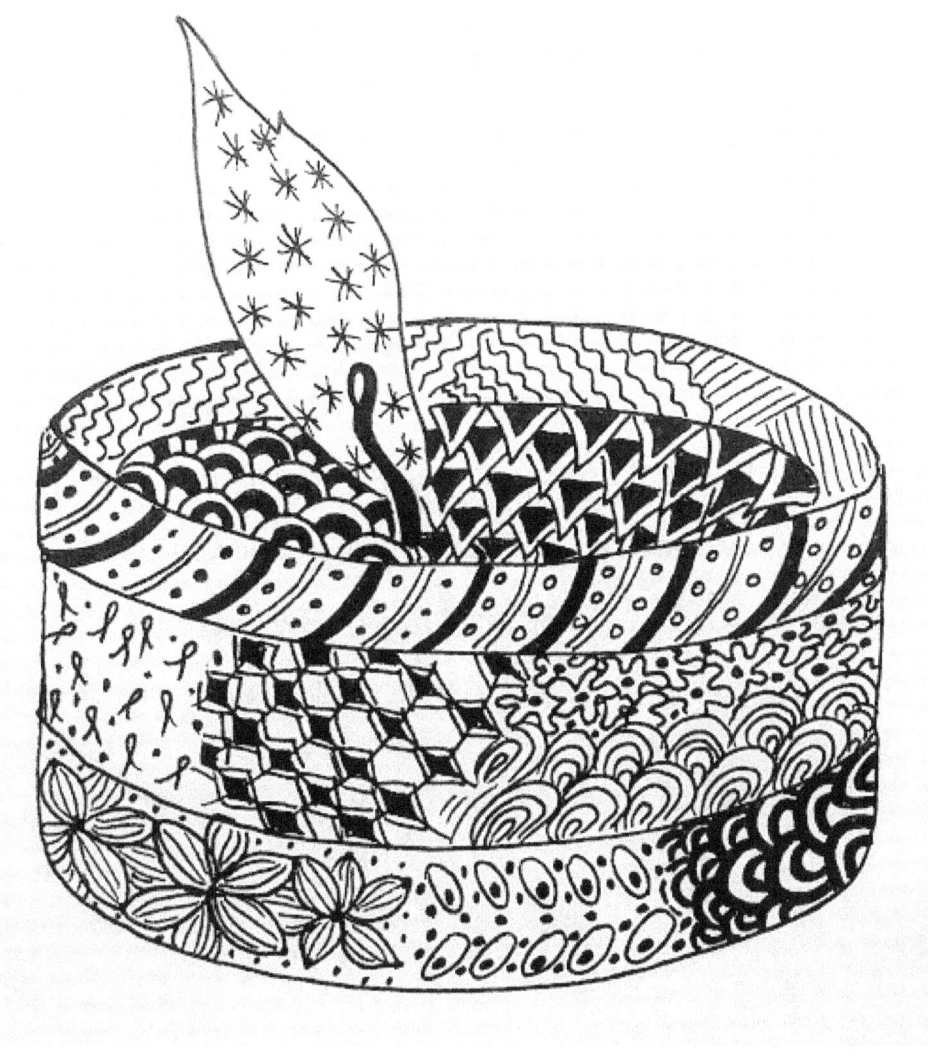

The final image shows our idea of a beautiful candle, covered with Zen doodles. However, you should not follow our advices at any cost. The whole point of this art is to free your mind and let it be creative. So, feel free to create as many patterns as possible.

Chapter 5 – Learn How to Draw a Padlock and a Key

In many paintings and drawings, the padlock is the symbol of unbreakable bonds between people. The key is often used as the symbol for unlocking hearts and minds. Whatever the reason might be for you to decide to make a drawing of a padlock and a key, you should draw it in the best possible way. By that, we mean using Zen doodle techniques. You start this journey by drawing the outline of the padlock and the key. Make sure that you add lines that will separate several areas inside of the padlock and the key, as well.

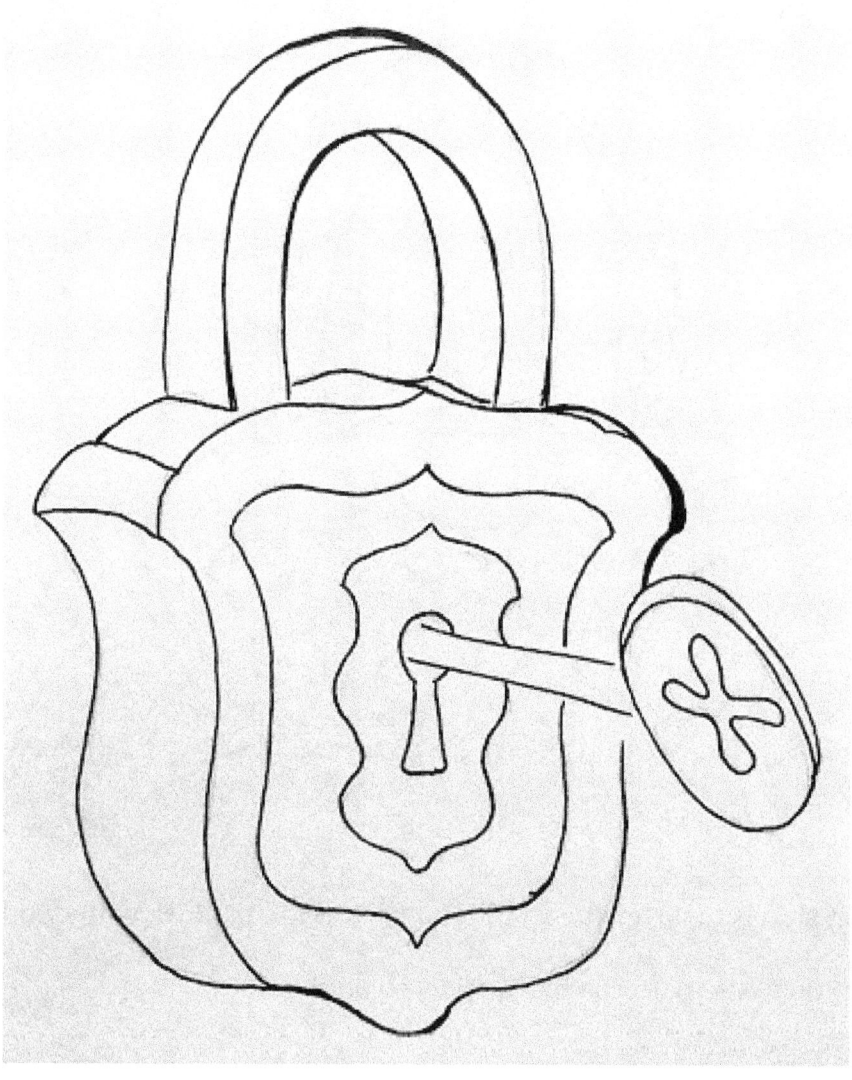

You should start with Zen doodling from the top left corner. Add bold lines, between which you can draw curvy zigzag lines.

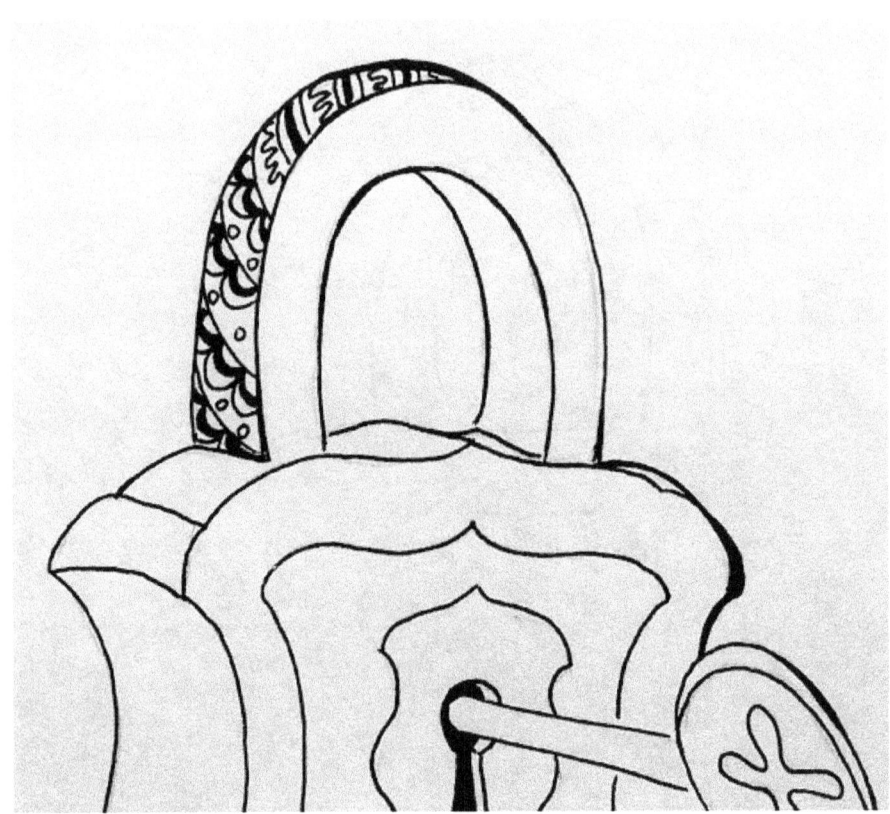

The next step is to cover the whole top part of the padlock with doodles. We suggest you to use patterns like flowers to do this.

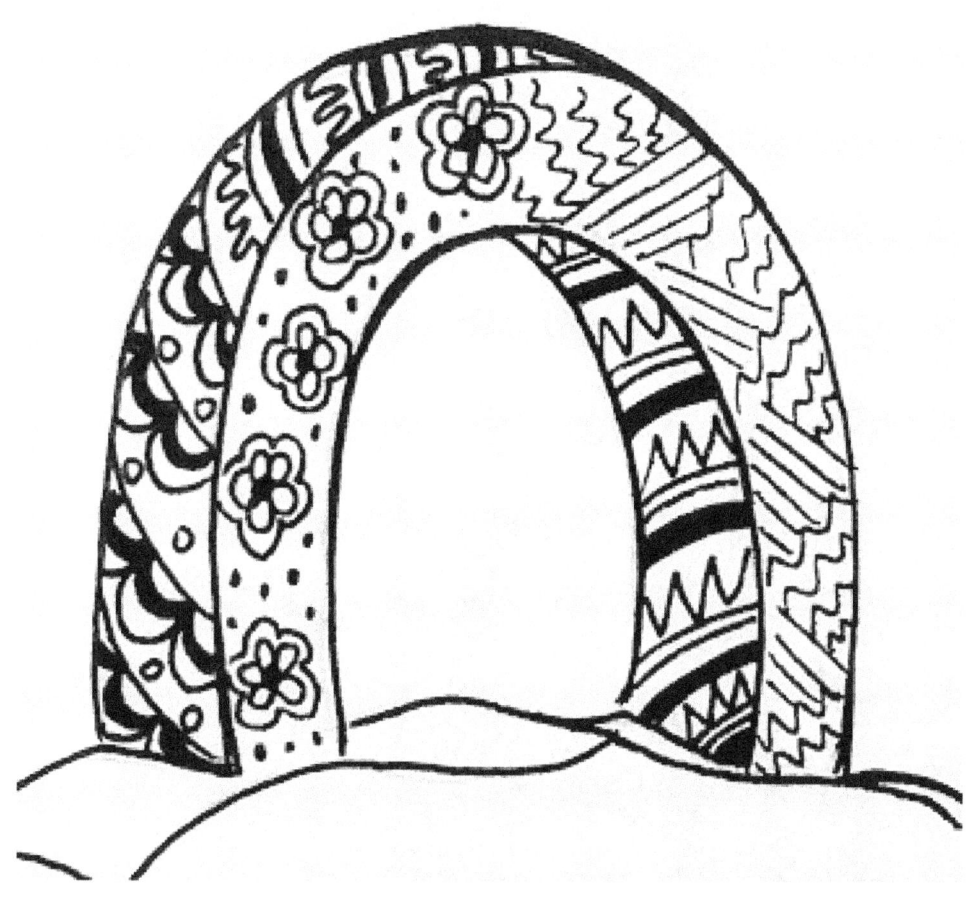

The time is now to move onto drawing Zen doodles in the middle part of the padlock. Draw shapes like wheels or snowflakes in circles. Also add a few rectangular shapes in one of the smaller empty areas of the padlock.

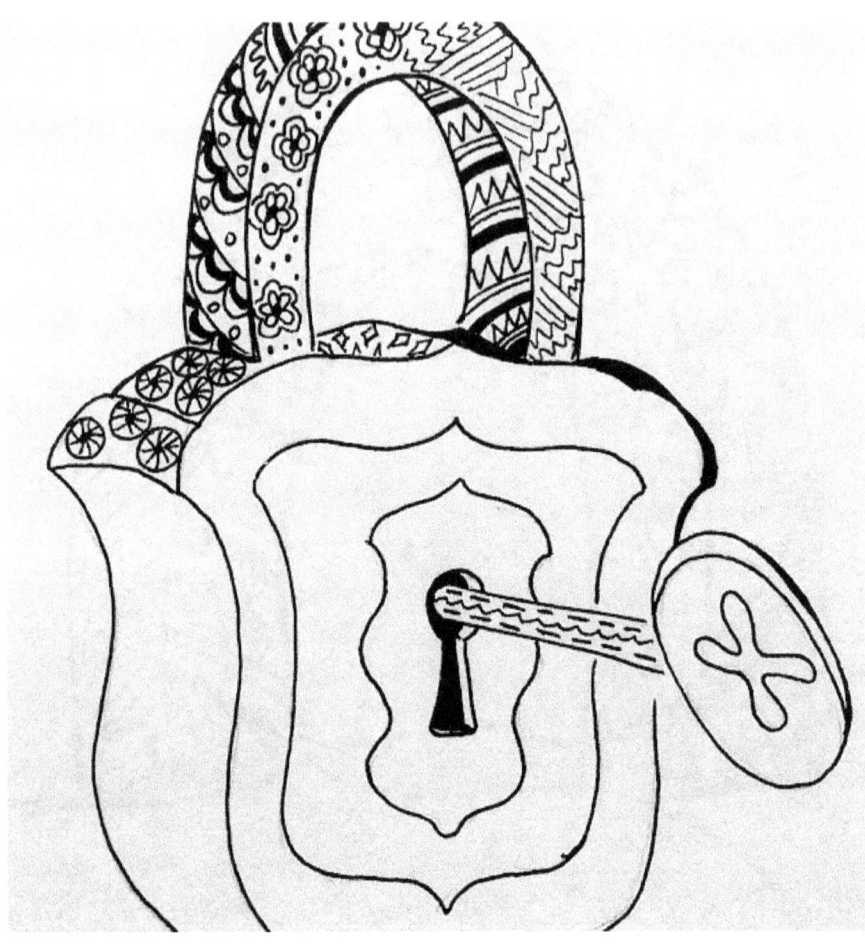

The left side of the padlock should be what you should cover in doodles next. We advise you to draw concentric lines, whether semicircular or straight. At this point, you should also start drawing the doodles on the key. You can use small dashes or a long zigzag line.

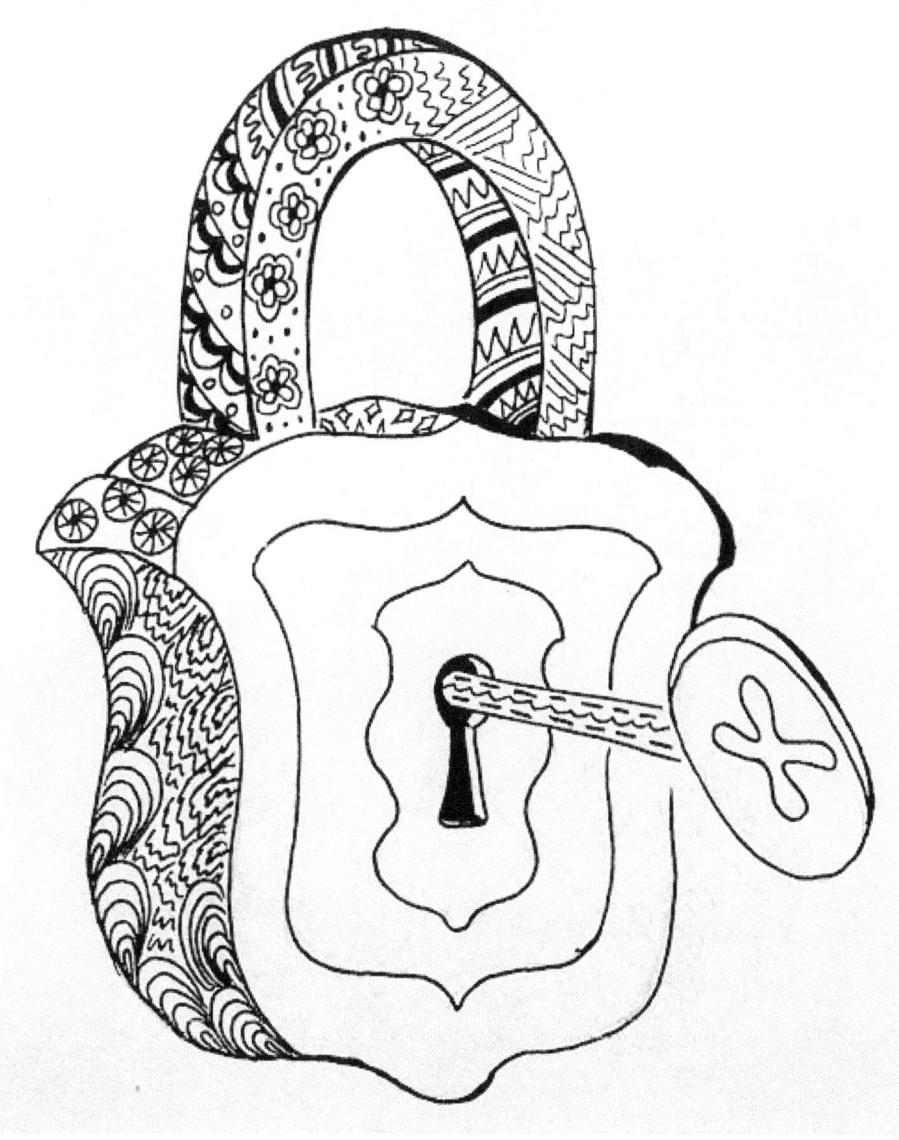

From there, it's time to draw Zen doodles toward the keyhole. If you've already separated the front part into several areas for doodling, you should start with the outermost, filling it with crescent shapes and dots.

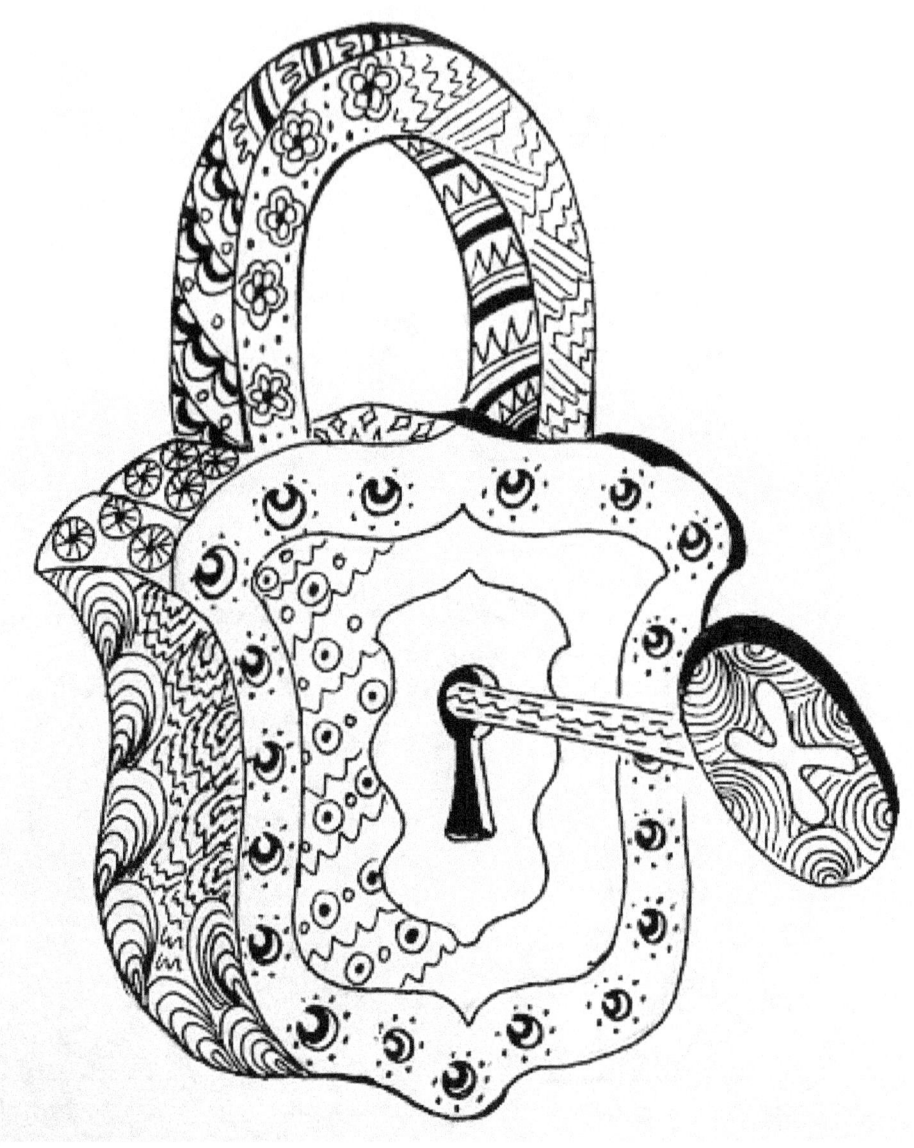

In the second area, add zigzag lines and more circles. Of course, if you have more ideas for interesting patterns, do not hesitate to use them. There is still plenty of room to add them.

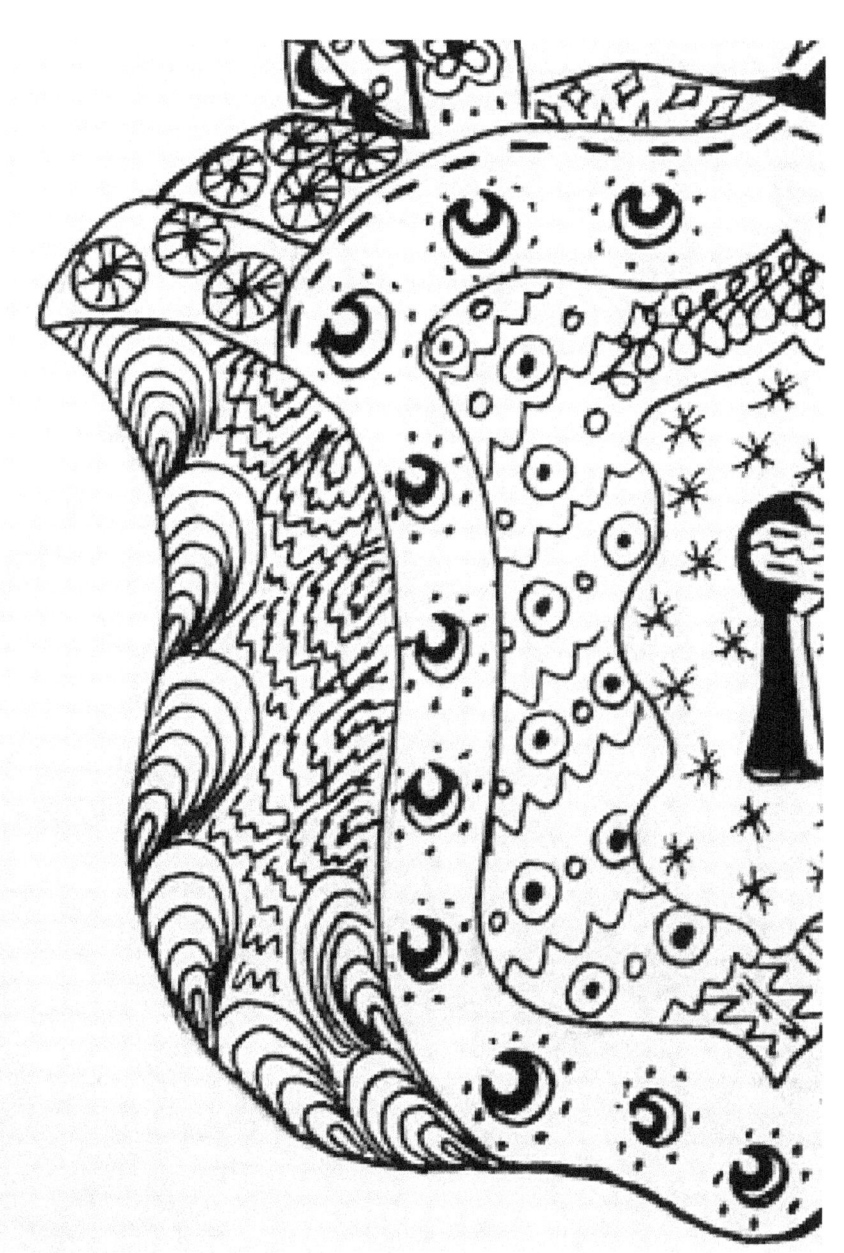

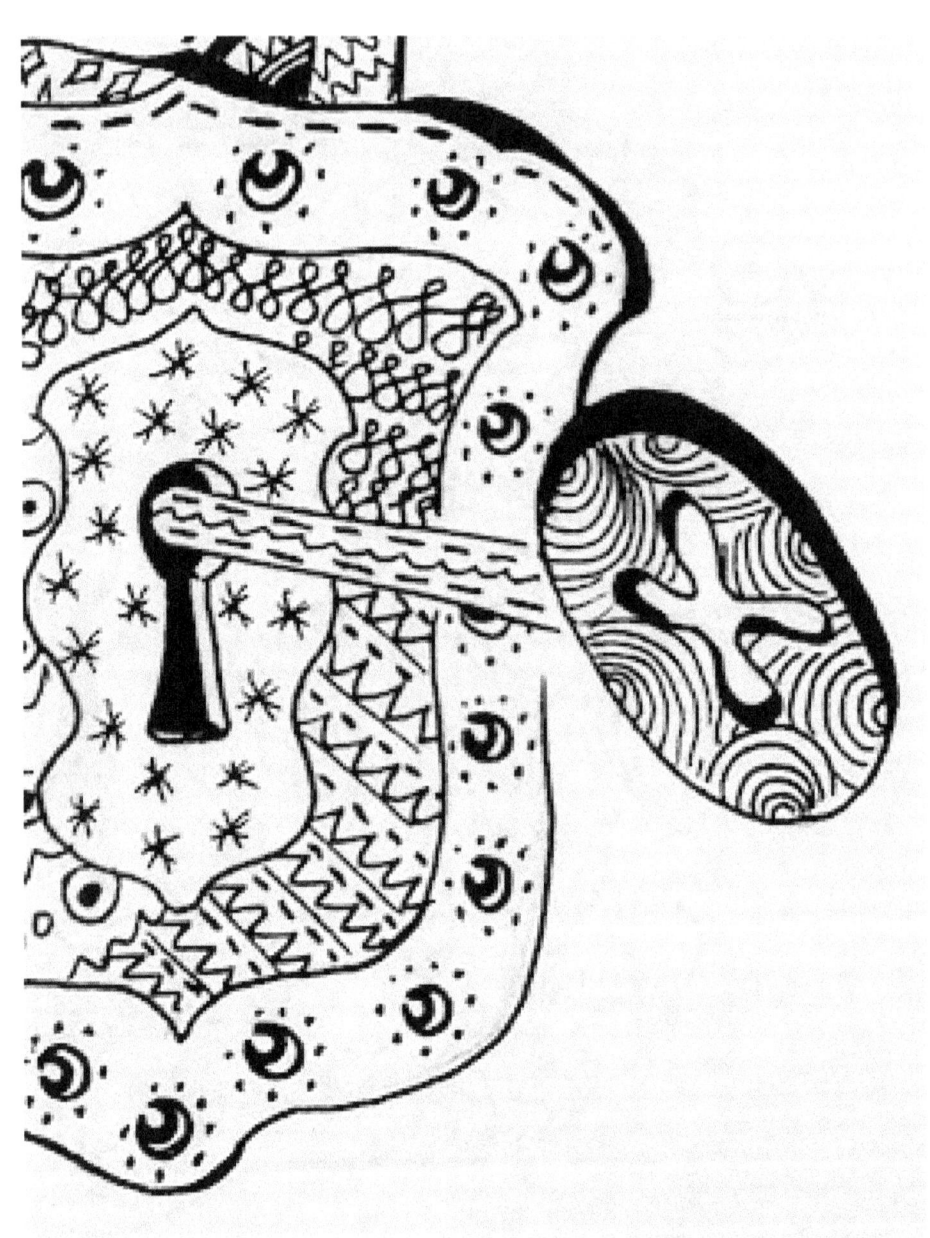

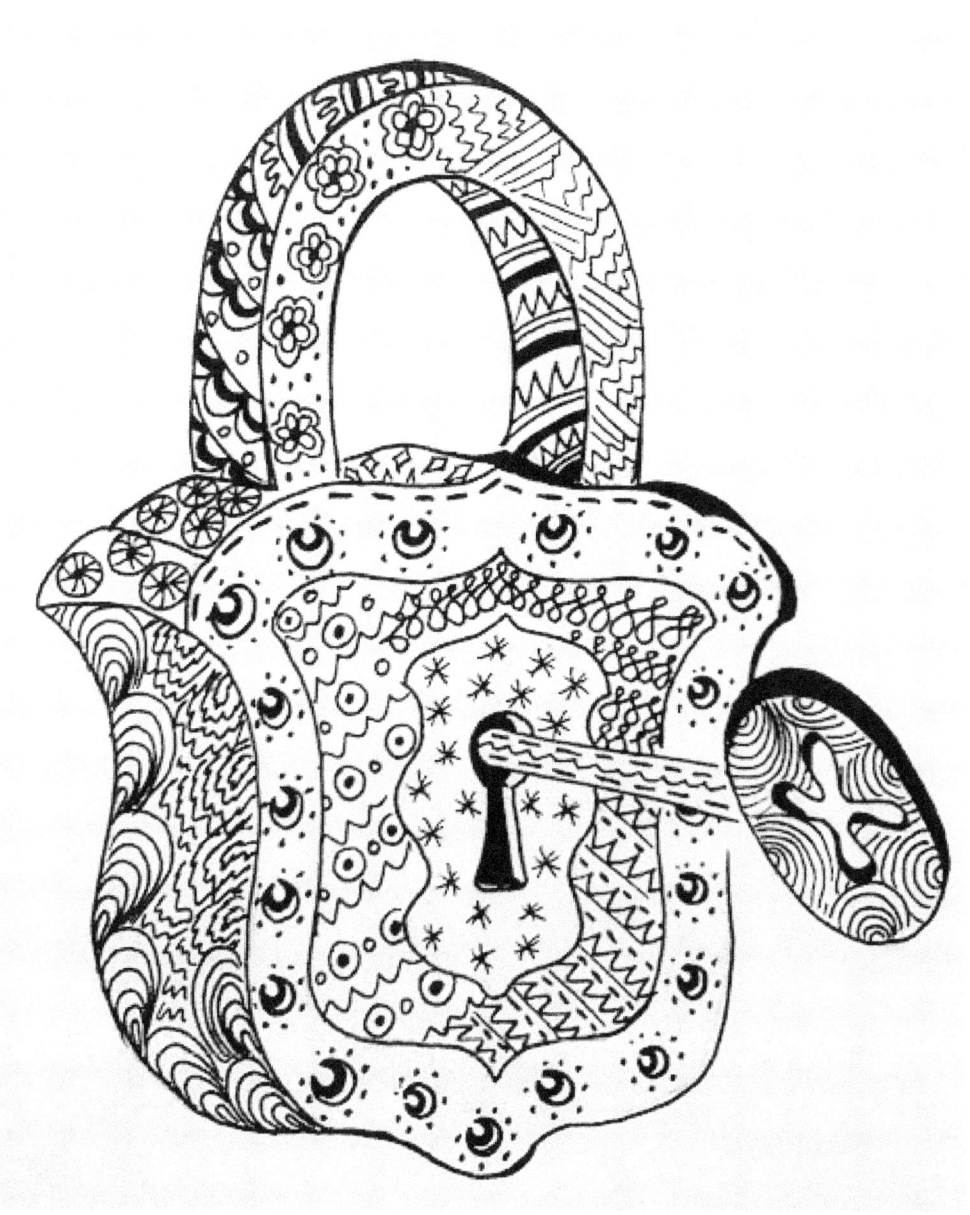

Cover the key with doodles as well. The same goes with all of the empty areas on the padlock. Some of the patterns you can use include snowflakes and small dashes. When you finish with that, your drawing should be complete. The picture above shows you how we did it, but your drawing of a padlock and a key should be different as every Zen doodle drawing is a work of art on itself.

Chapter 6 – Easy Zen Doodle Technique for Drawing Hands Holding a Pen

The final example in this book is probably the most interesting one. It's a drawing of the hand drawing Zen doodles. This image has so many areas for drawing doodles, which allows you to be very creative. You can use so many doodle patterns for this drawing as you can draw them on the hand, on the paper, on the pen, etc.

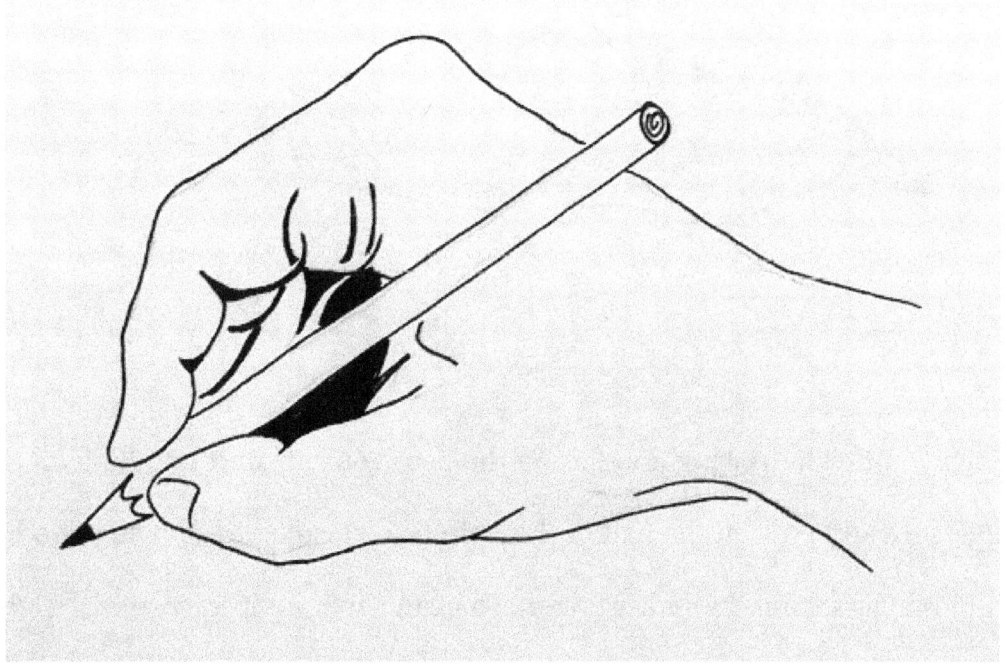

So, once you are done with drawing the hand and the pen, you are free to start doing the Zen doodles. As you can see in the image below, we started with the pen and you should do the same. You can unleash your imagination and use as many different patterns of Zen doodles as you like. In this example, we used dots, stripes, semicircular lines and zigzag lines.

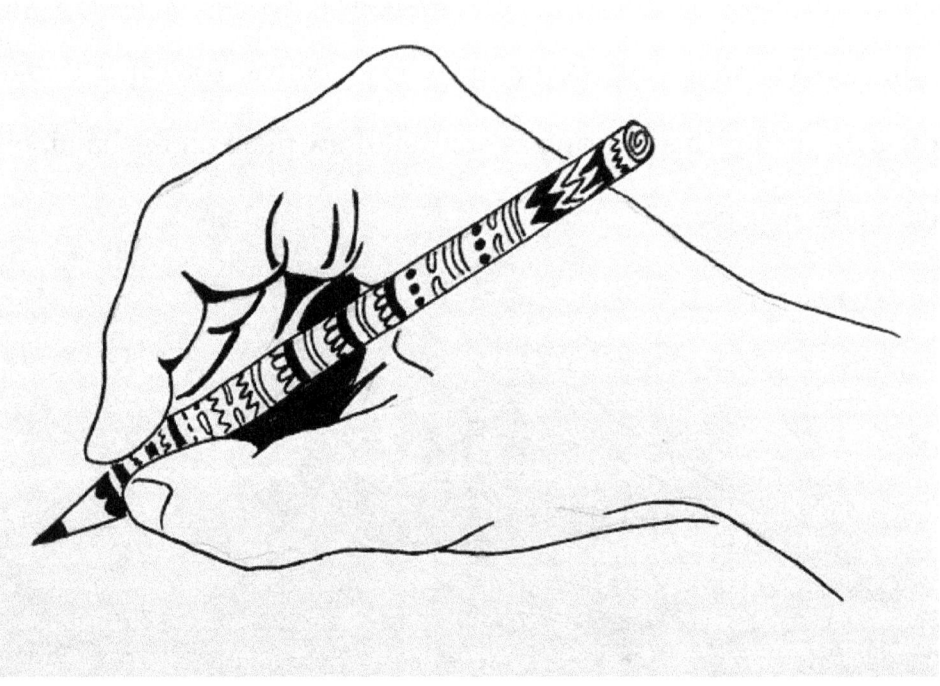

When you finish drawing doodles on the pen, you can start doodling on the fingers. Draw spots on the nail of the thumb. You can start drawing doodles on the fingers from the index finger. You can separate it into several areas, so you can use many different patterns, same as we did in this example.

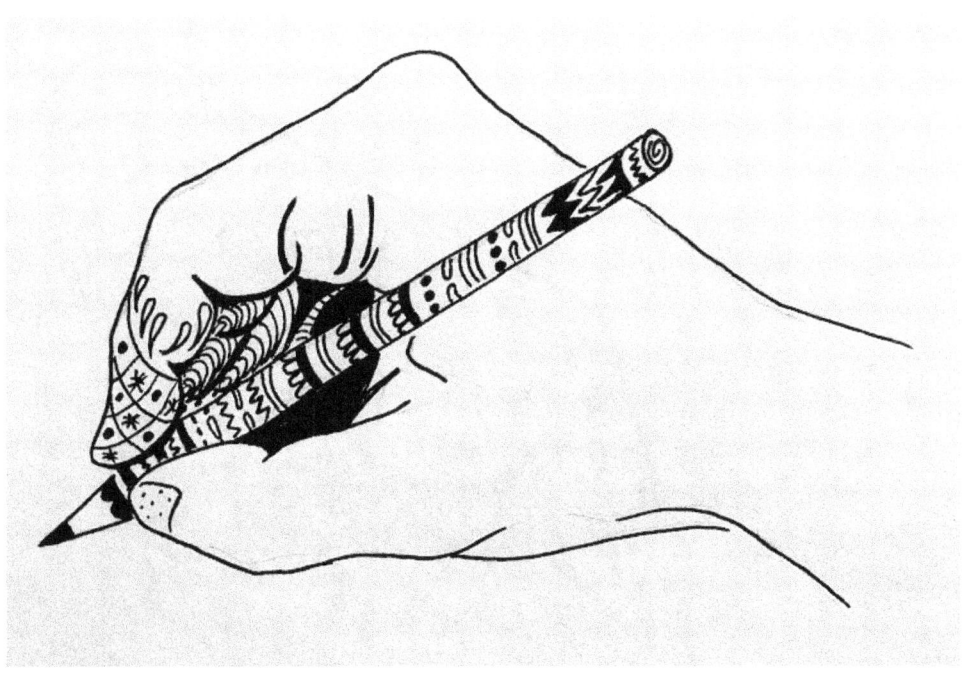

Now it's time to cover all fingers with doodles, apart from the thumb. Use shapes line stars, dots and snowflakes. Let the pen be the mark that separates the hand into two parts.

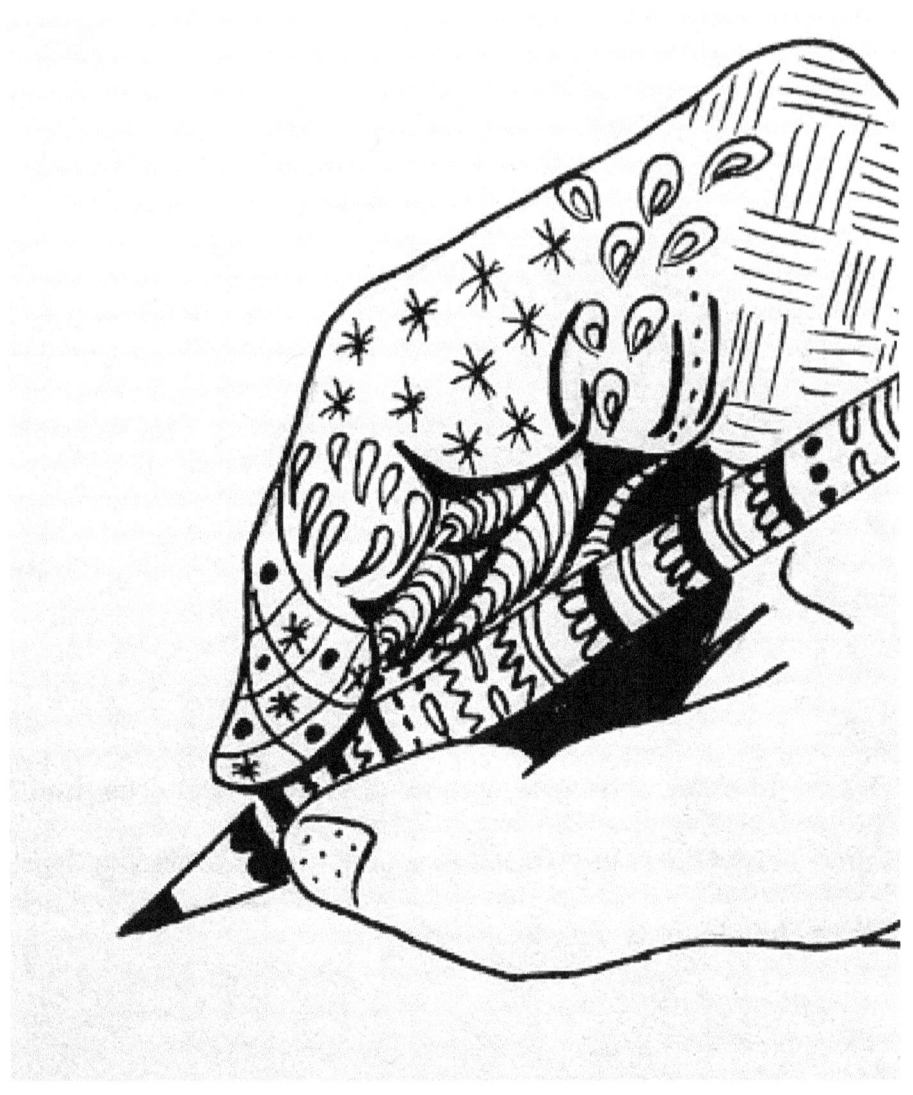

The next step is to keep on doodling till you cover the whole hand. We advise you to start from the thumb. Start doodling by drawing spiral patterns that resemble snails. Add also some spiral lines, flowers and leaves.

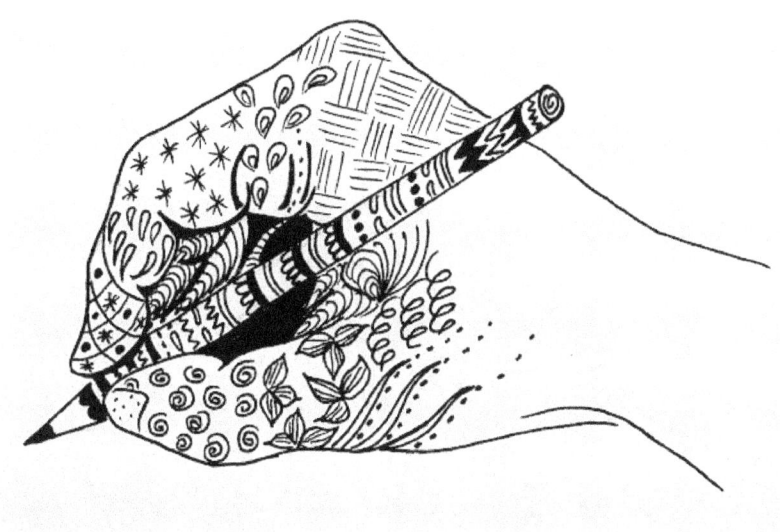

Before finishing the drawing, you have a chance to be as creative as possible and do a huge number of different patterns of Zen doodles. At this point, there's still a lot of empty room for your doodles.

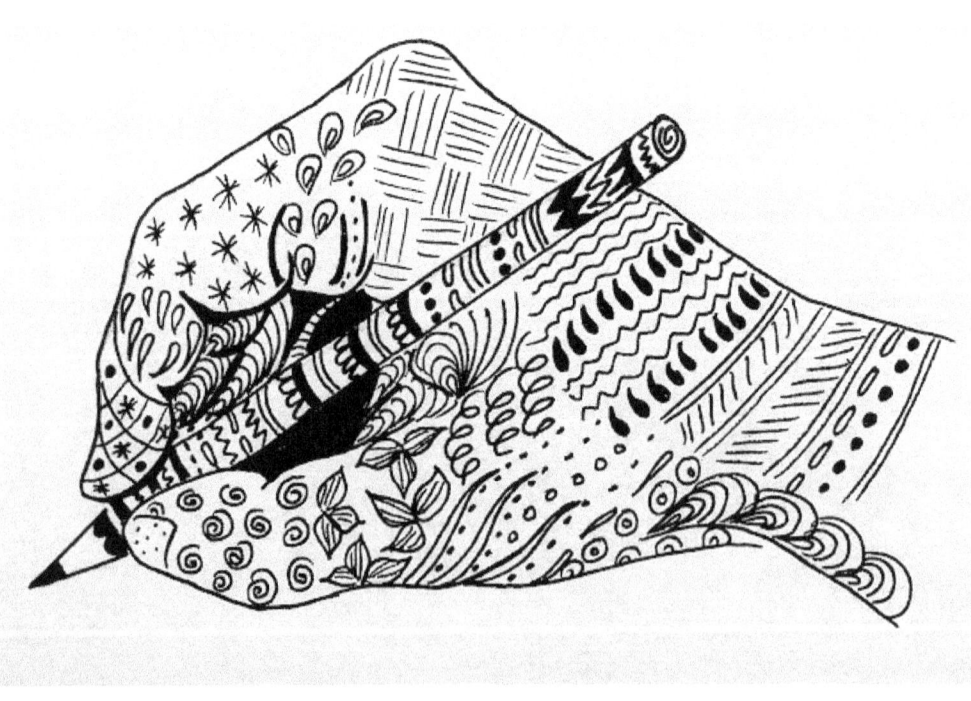

The image above shows you how the final drawing should look like. Of course, you are not obliged to follow our instructions strictly. We simply provided you with these images to inspire you to do your own drawings. Hope this wonderful Zen doodle drawing of a hand and a pen will inspire you to draw your own pictures.

Conclusion

If you're looking for a hobby that will combine art and meditation, look no further than Zen doodle drawing. It's a form of art meditation that ally works for a number of people. Zen Doodle drawing will set your mind free, making you more creative and ready to tackle any of the life's problems.

Once you get into the flow, the inspiration will kick in and you will start creating beautiful drawings. However, this will not limit your mind only to drawing. This practice can influence your brain to be creative about so many things, not related to art. Some people have found that Zen Doodle drawing has turned their lives for the better, because it helped them be more creative when looking to solutions for certain problems.

Zen doodle drawing is an art in which you draw repetitive patterns, without an end goal of the drawing and that's exactly what allows your mind to be free from any obstacles. That is the only way your mind can express its creativity to the fullest. There aren't many arts like Zen Doodle, which will help your mind produce exactly the art it wants.

Not only do Zen Doodle drawings look awesome, they can also have a lot of benefits for your mind and body. Many studies have been done in order to find out whether there's truth to the claims that Zen doodle art can really help people. Perhaps surprisingly, the research has shown that it's absolutely true! In fact, Zen Doodle drawing has more health benefits than anyone had expected.

Zen Doodle drawing is proven to have effect on mental and emotional health of people, which is why it is recommended as a way of practice for counseling. Zen Doodle drawing also proved to be a great way to fight anxiety and depression. Actually, a research has shown that cancer patients react nicely to Zen doodling.

Drawing as a form of therapy has been around for years, but lately scientists have been starting to agree that it definitely has a positive effect on the mind, allowing people to establish a control over their focus and hand movements. Try it when you are feeling angry and consciously direct your hand to draw a circle. You will notice that maybe your handshakes or you grip a pen too hard, all of which are major indicators of how your body reacts. If you cannot calm down the mind, you can always calm down the hands and body.

But don't do Zen doodles only when you are under stress. Do these drawings when you are calm, as well. Note the similarities and differences between the drawings that you drew when you were sad with those you did when you were happy.

Usually, when you're calm your Zen Doodle drawings will not have too many details on the circles; these are usually simple shapes with greater distances, while when you're sad or angry, the drawings will have more details.

Psychologists suggest that doodles can visualize your subconscious. Drawing Zen doodles will bring you in touch with your inner self, with what your mind really thinks. You can find out who you really are with this art. Zen Doodle drawing will help you unlock ideas that might have been stocked deep in your mind for years.

You will notice that your drawings change constantly. One day you'll be drawing circles, the other triangles. It might seem pointless to keep track of the artwork, but that's far from the truth. The Zen Doodle drawings are a proof of your state of mind at this period of life. You can always use them in future as a reminder on a certain period of life.

The art of Zen doodle drawing has becoming more and more popular, all around the world. There are lots of reasons for this, but the most important include the following:

- Zen doodle drawing helps people become calmer and more focused.

- It boosts creativity. Same as any other art, Zen doodle drawing is a great way to become more creative and produce new ideas.

- It reminds people that do not need to grow up.

- It deepens the relationship between parents and children. Zen doodle drawing is definitely a good way of spending quality time.

- Because of all of the reasons mentioned, people can learn more about themselves

That said, you have no reasons to wait to start with Zen doodle drawing. This is an art and a hobby that doesn't require much, but gives a lot instead. All you need is a pen and a piece of paper as Zen doodling is not about material, but about spiritual things.

If all of the reasons mentions above are not enough for you fall in love with Zen doodle art, we urge you to give it a try by drawing one of the examples given in this book. Once you do it, you'll surely want to do more!

Other Books from Daniele Ling:

ZEN Animals:
A Complete Guide to Master Wild Animals Drawing in Zen Doodle

Drawing People in Zen Doodle Technique:

Unleash Your Creativity with Unique Zen Doodle People Drawing

Zen Doodle Cats:
Drawing Zen Doodle Cats Made Easy

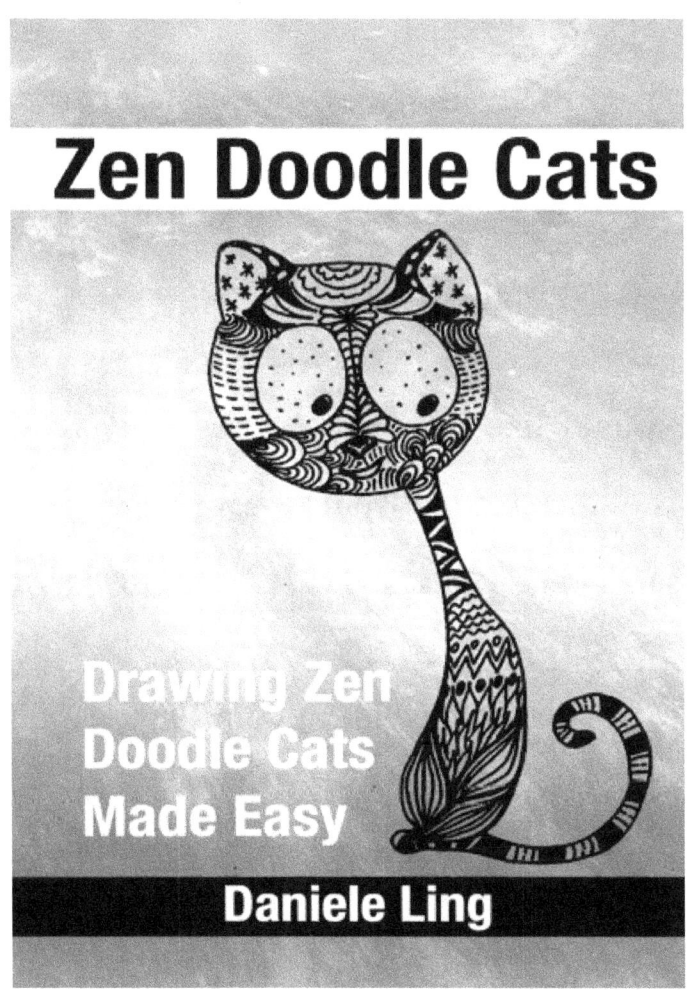

Thank you!

Thank you for choosing our book, we hope you found it interesting and helpful.

If you liked the book, please give us a favor to write your review.

We would really appreciate this!

If you would like to have a bonus – **FREE BOOK**, please send the screenshot of your review to this e-mail: **e-mail** and we will send you a **FREE BOOK** in PDF as a **GIFT**!**

Hope to see you in our future books and good luck in your drawing experience!

**** in the e-mail subject please mention the name of the book you reviewed and the author.**

www.ingramcontent.com/pod-product-compliance
Lightning Source LLC
Chambersburg PA
CBHW080722190526
45169CB00006B/2482